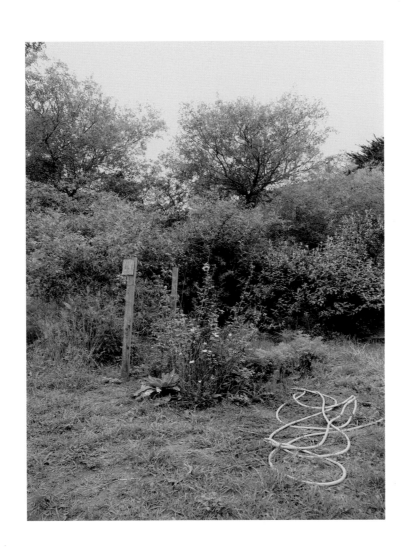

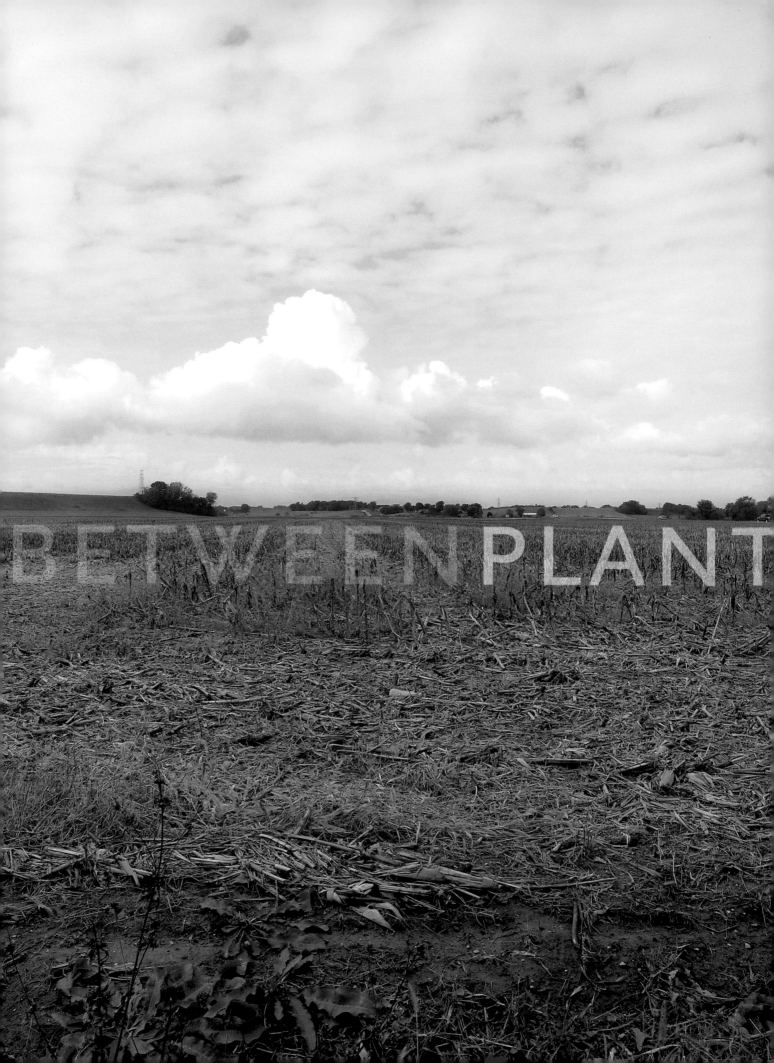

SANDI HABER FIFIELD

NGANDPICKING

ESSAYS BY
DOMINIQUE BROWNING AND LESLIE K. BROWN

CHARTA

For John, the salt of the earth.

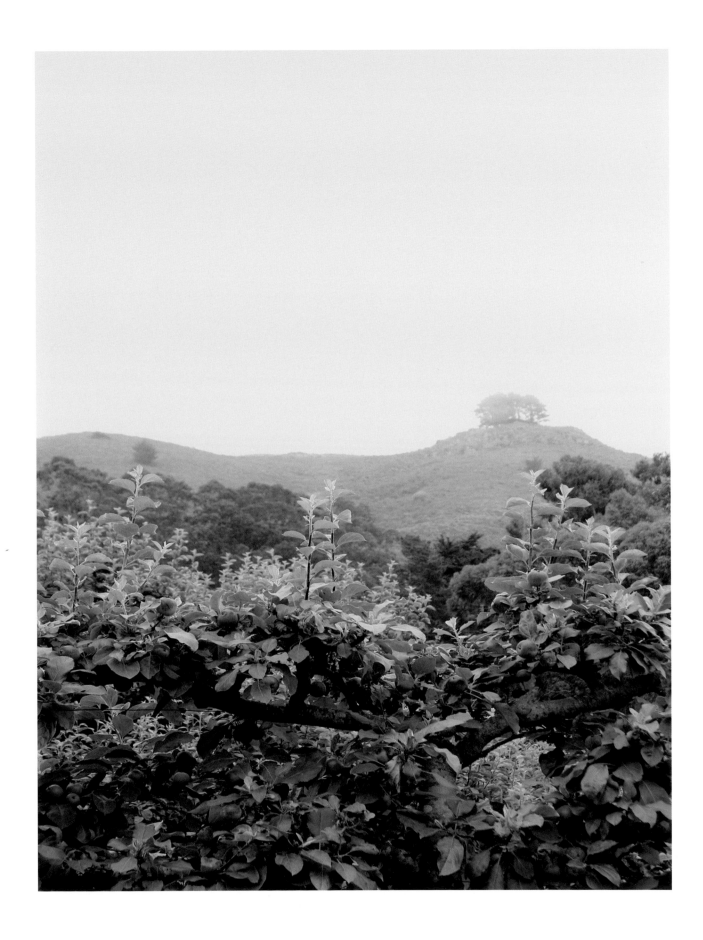

When I lived in Paris in the early 70s, I did my food shopping at fresh air markets every day. This was a novelty; where I grew up, in Connecticut, you did your shopping out of the freezer. Every morning, carrying my string bag, I jostled with the matrons at the turnip bins, tripped over kittens mewling around the dairy stands, goggled at the stripped, muscled carcasses of cows and rabbits, savored the fragrance around the baguettes and had my hand slapped when I tried to pick through the apple bin. I loved it. The food was delicious, and I knew where it came from, and even who grew it. I knew because the farmers were the ones slapping my hand, or teaching me how to cook a turnip.

When I returned to the United States, the fond memory of French food became hazy. I spent years getting my food the same way most of us did: I drove to antiseptic supermarkets full of perfectly formed but bland produce. It has taken thirty years – finally! – for us to appreciate what we once had, and to return to the way things used to be. Old-fashioned farmers' markets are flourishing all over the country. Whether we live in bustling metropolises or out in the rural hinterlands, we are now blessed with an alternative to meat and produce from industrial farms. We can find old world, slow food, grown with durable love and respect.

What's even more surprising is that an entirely new generation of farmers is coming up. Men and women in their twenties and thirties are returning to the land. Their heads might be full of soil science, but their hearts are full of dreams. Many of them are publishing memoirs about their experiences – and the best of those are equal parts funny and sobering. For there is one thing that tends to be forgotten in our nascent romance with local honey and pocked apples and raw milk and gnarly, multicolored carrots: every single thing that is put on the farmer's sales table is the result of back-breaking effort. Farming has always been, and will always be cruelly hard work – even while it is a primal, joyful endeavor. It is this yin and yang of pleasure and pain, work and rest, beauty and utility, tidy and messy, bounty and loss, that Sandi Haber Fifield so artfully captures in the photographs presented in *Between Planting and Picking*.

The hand of the farmer is everywhere seen. These are pictures of what is going on behind the scenes of bountiful display at the farmer's market. The scrawled note, held down by a rock on the small wooden table, pleading for the return of a vase, tells the story of a gardener betrayed; she has

trustingly sold her flowers on an honor system. The child's bicycle leaning against a stack of crates under a table, next to the garden cart, in front of which sits a proud dog, tells the story of an active, engaged and connected family. The shovels and hoes and rakes leaning against the plastic deer fence tell us about a gardener's efforts to maintain a boundary between his tamed plot and that of the wild creatures. The tumbling stacks of cardboard boxes piled on and around a table in the corner of a plastic greenhouse tell us about how much busyness there is in getting produce out the door.

These are pictures whose beauty lies in the gritty truth of hard, dirty work. Furniture is knocked together and barely standing, piping is strewn on the ground, plastic bins are overturned, vines wilt and shrivel on metal tubing, blooms grace jelly jars. The pictures are full of tables, and that is perhaps not surprising, for tables, much more than anything else, are what the farmer needs — for seedlings, for grafting, for thinning, for potting on, for display and for selling. There are not so many chairs in this world, for there is not so much time to sit. One white plastic chair lies on its back, as if it were in a dead faint, overturned, perhaps, in exhaustion after having harvested dozens of pumpkins.

It is people who do the planting and the picking, of course, and all the labor in between. But it is the hand of nature that has the ultimate rule. Every day of a farmer's life brings new, uncontrollable or unforeseen drama. A season, with its large investments of time and money — and sometimes, terribly, an entire livelihood — can be wiped out in a week of hard rain or a month of scorching sun. For what? For the pleasure of being the one to coax up out of a seed buried in the earth the sustenance that will keep an entire community growing and healthy. A family farm, run by people who know exactly who they are feeding, is a vital link in a generational chain of being.

No. Let's make that a chain of thriving. We can all easily "be"; we can simply get by — though it won't be in a healthy manner — with fast food, industrial food, chemically-laced food, food that comes of creatures stressed and abused and tortured. We can be, but we will not be thriving. Smaller farms offer a way of nourishing ourselves that is responsible, soulful, and cherishing of our earth and all that sustains us. It is that basic. And that enormously ambitious. Between planting and picking, we celebrate the fertile ground of simple, profound, renewable values. Home grown, and good for you.

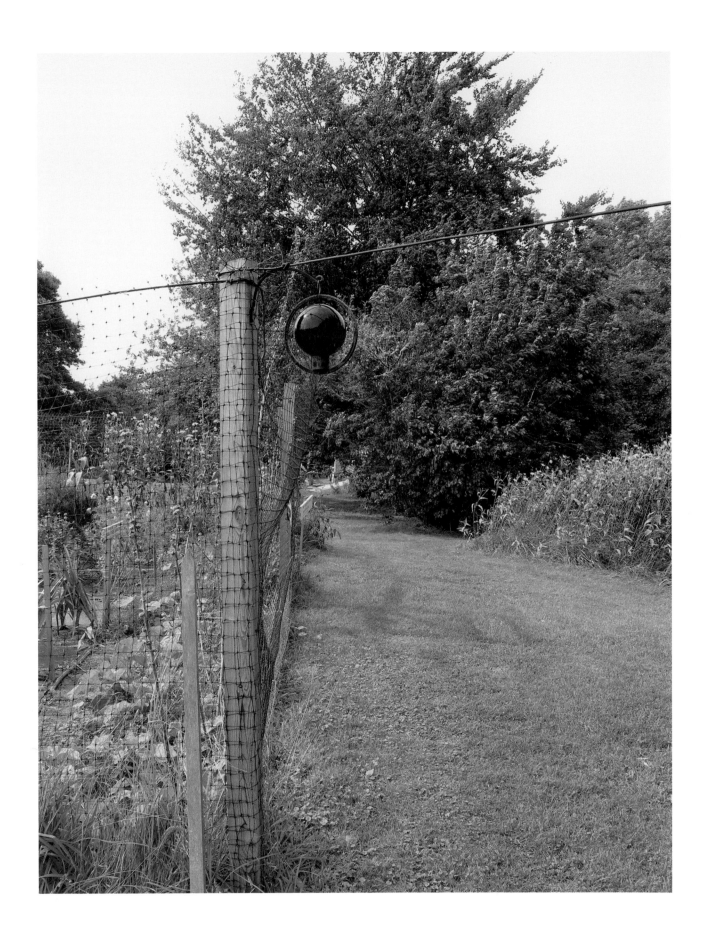

PLATE 1

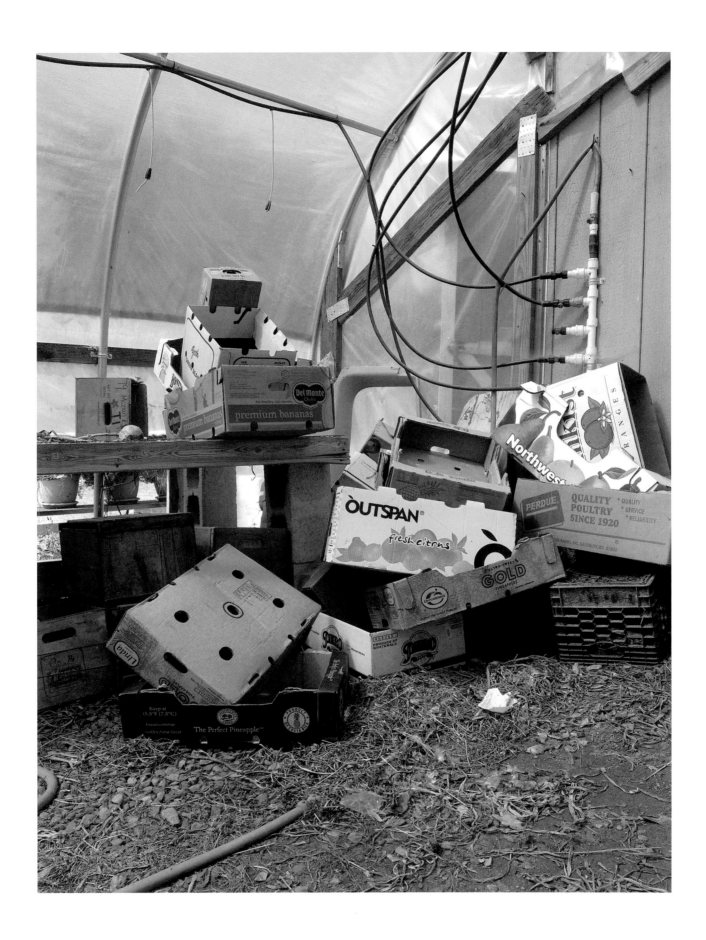

PLATE 2

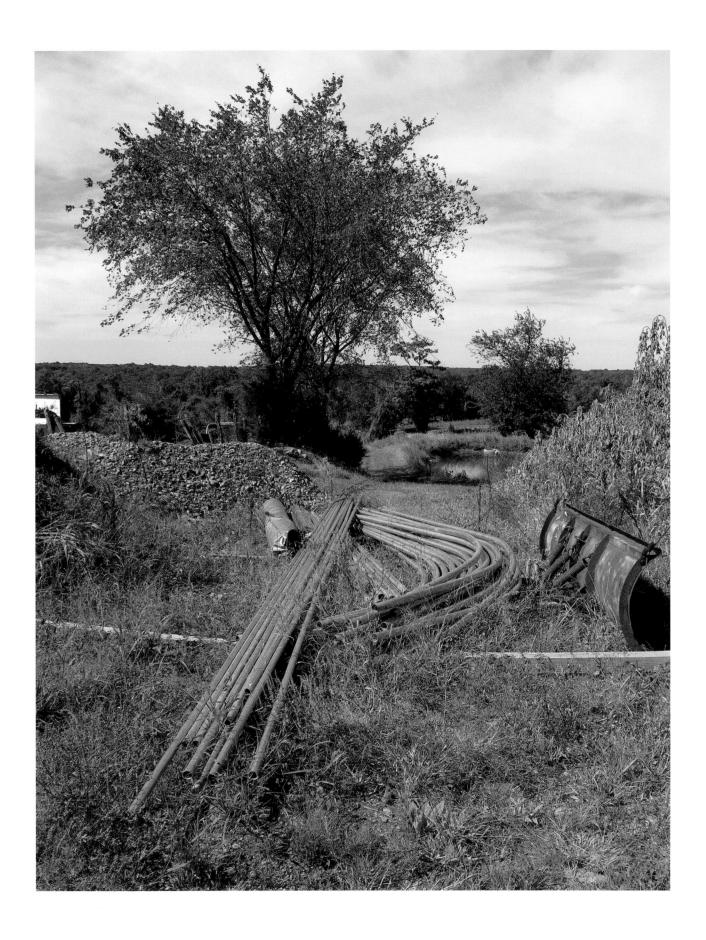

PLATE 3

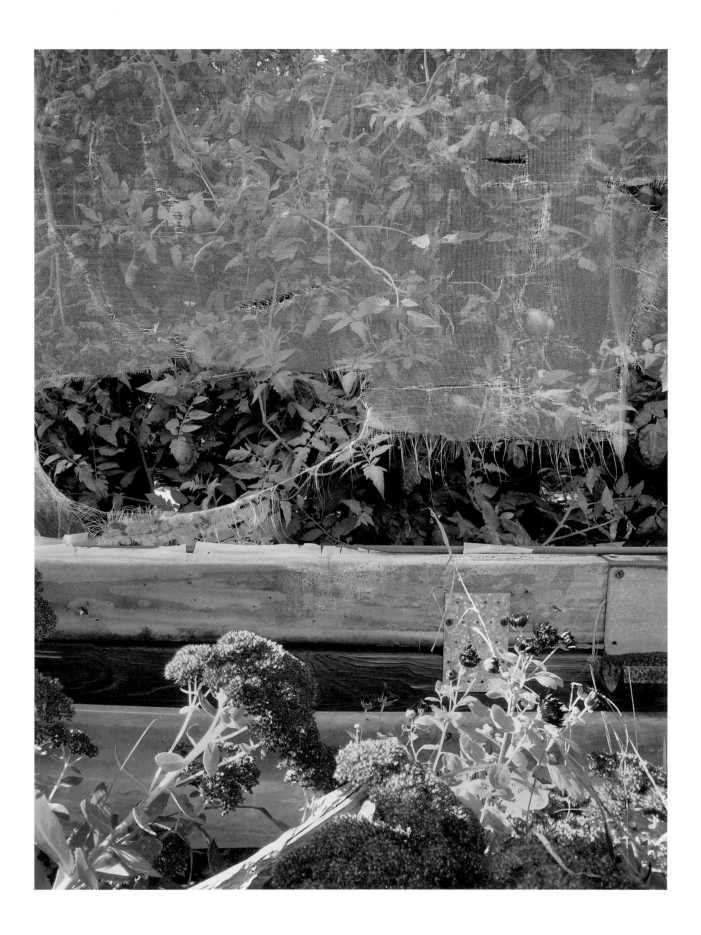

PLATE 4

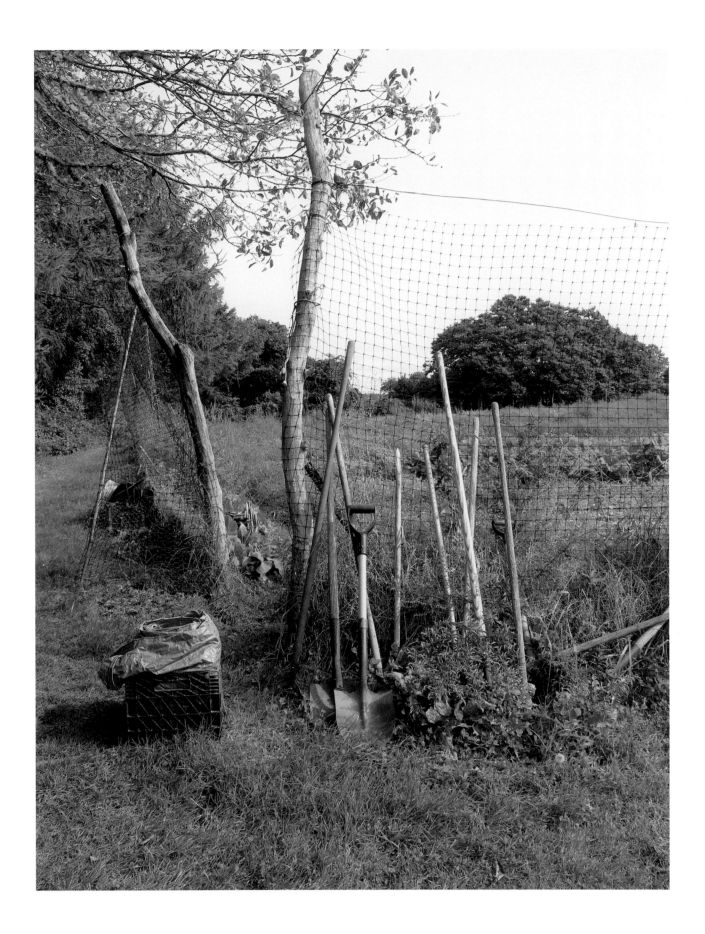

PLATE 5

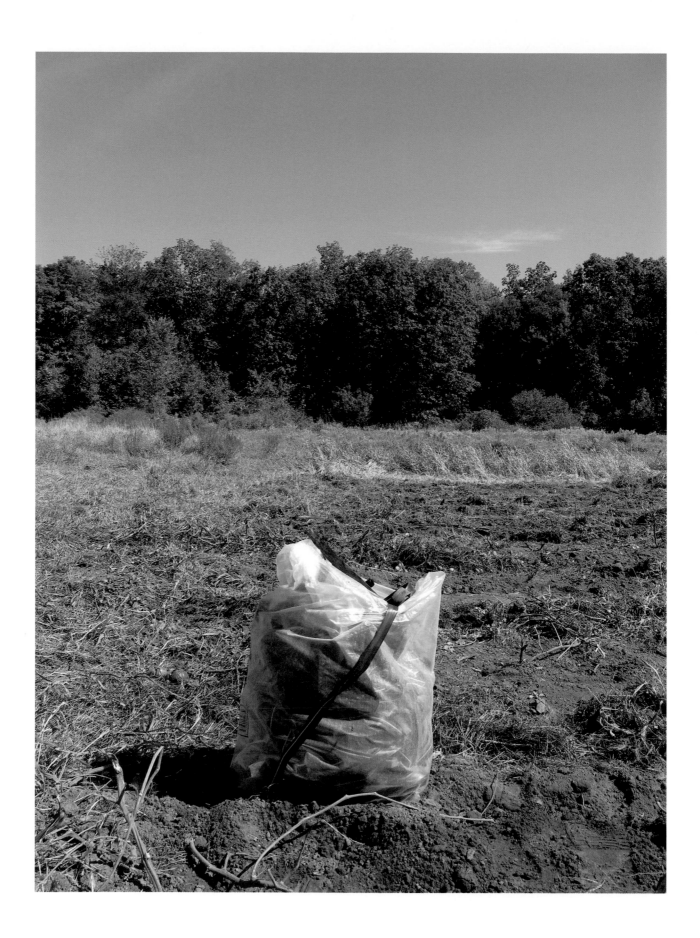

PLATE 6

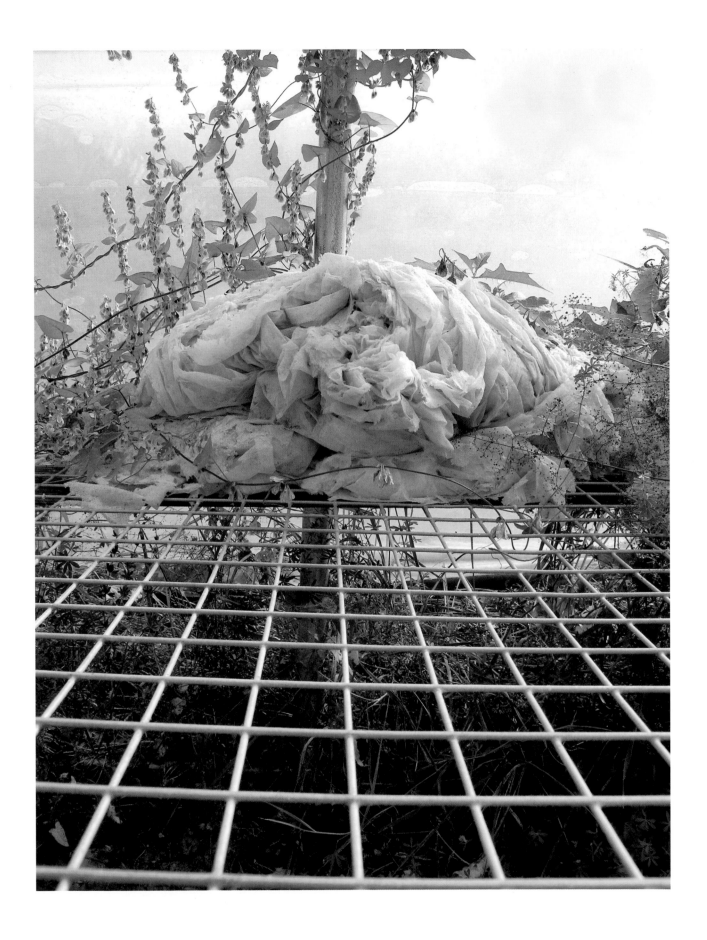

PLATE 7

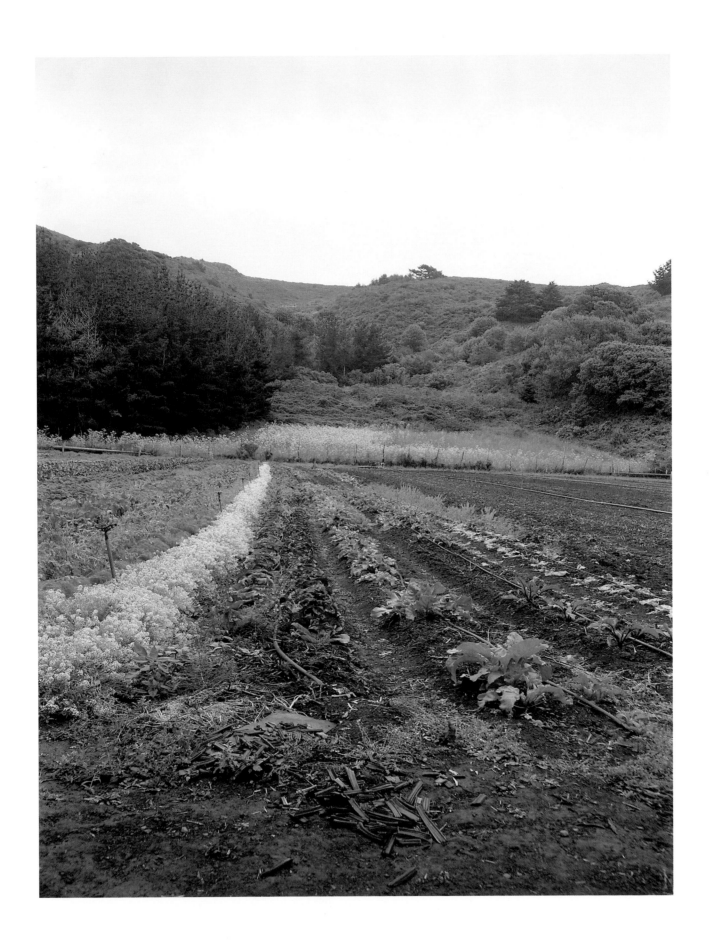

PLATE 8

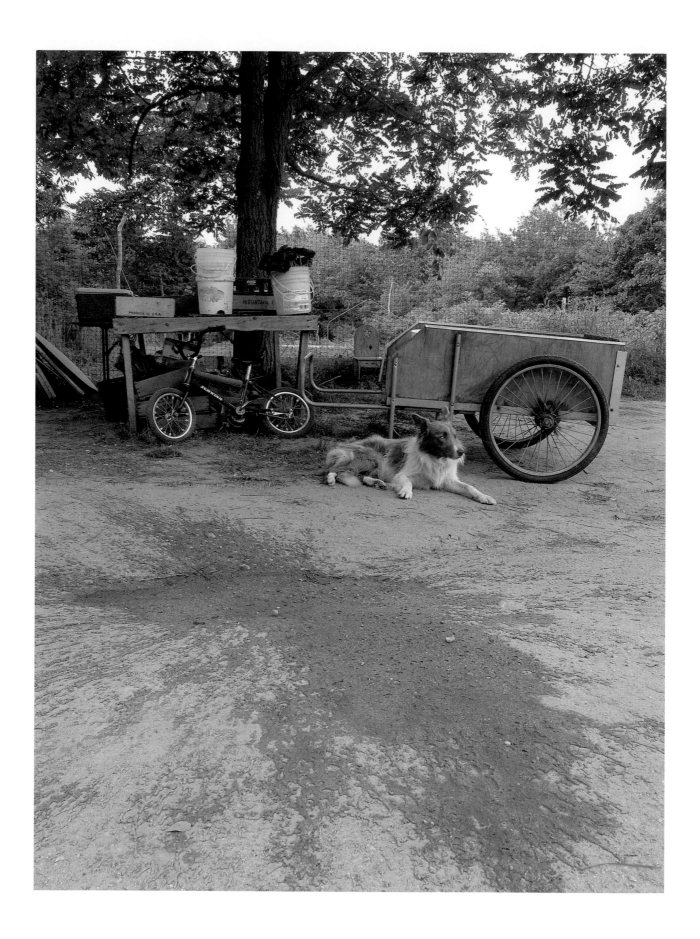

PLATE 9

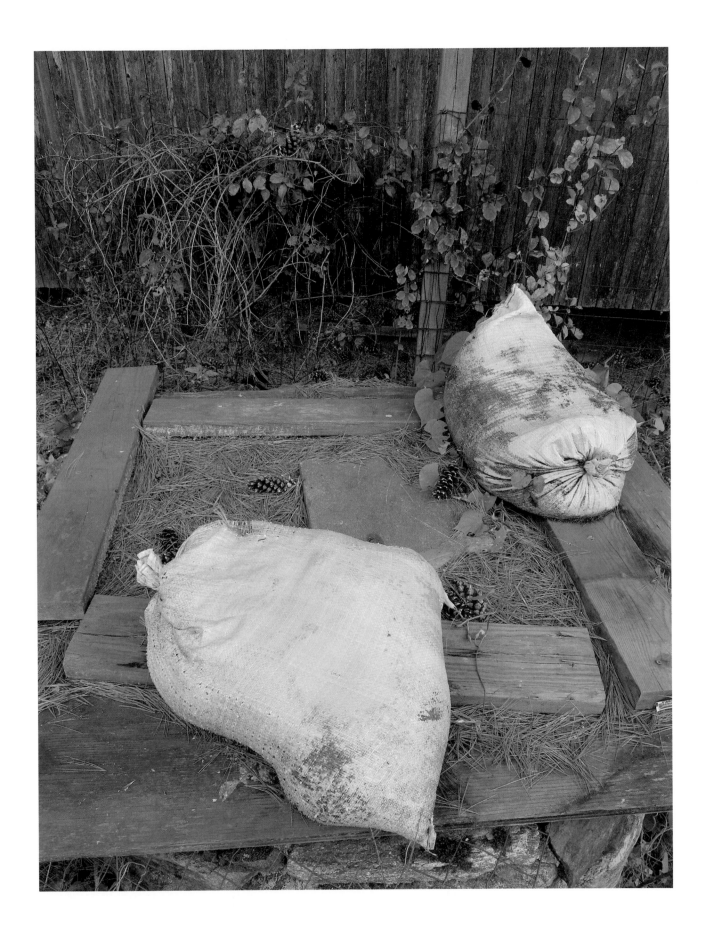

PLATE 10

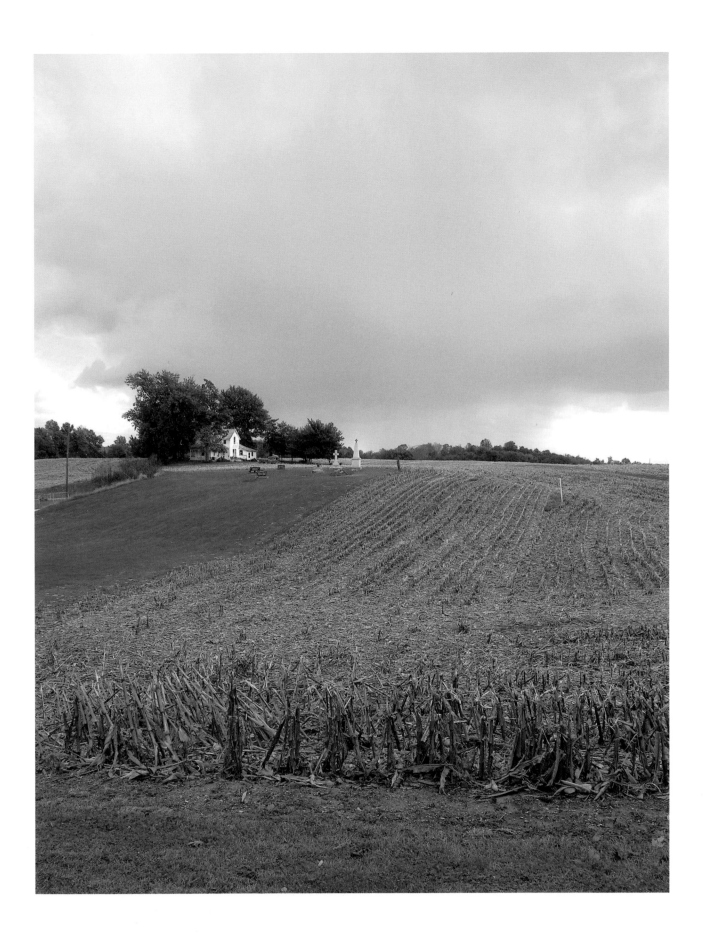

PLATE 11

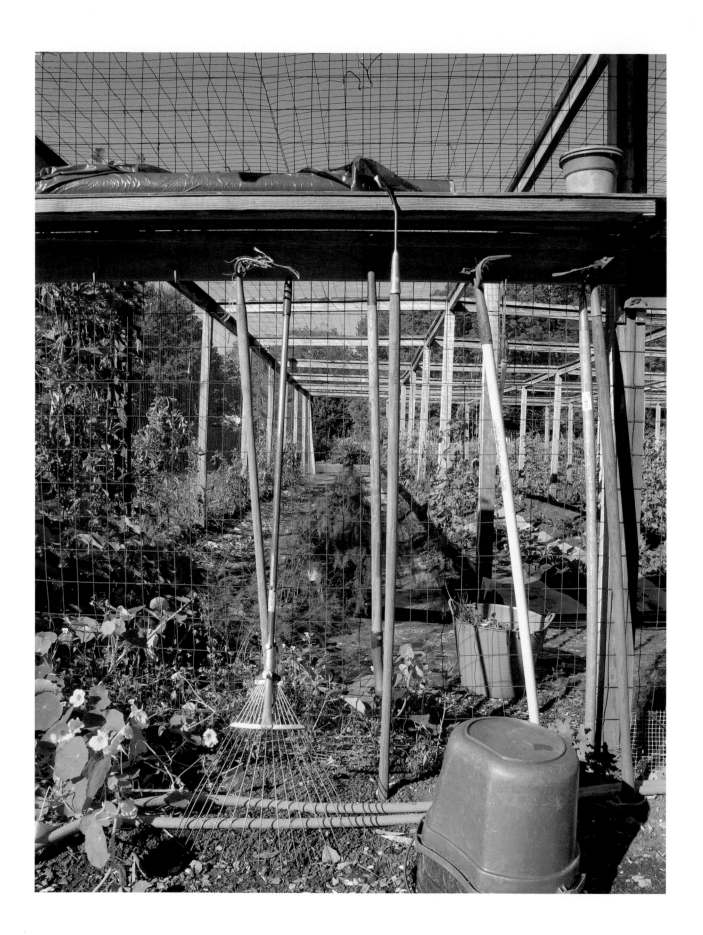

PLATE 12

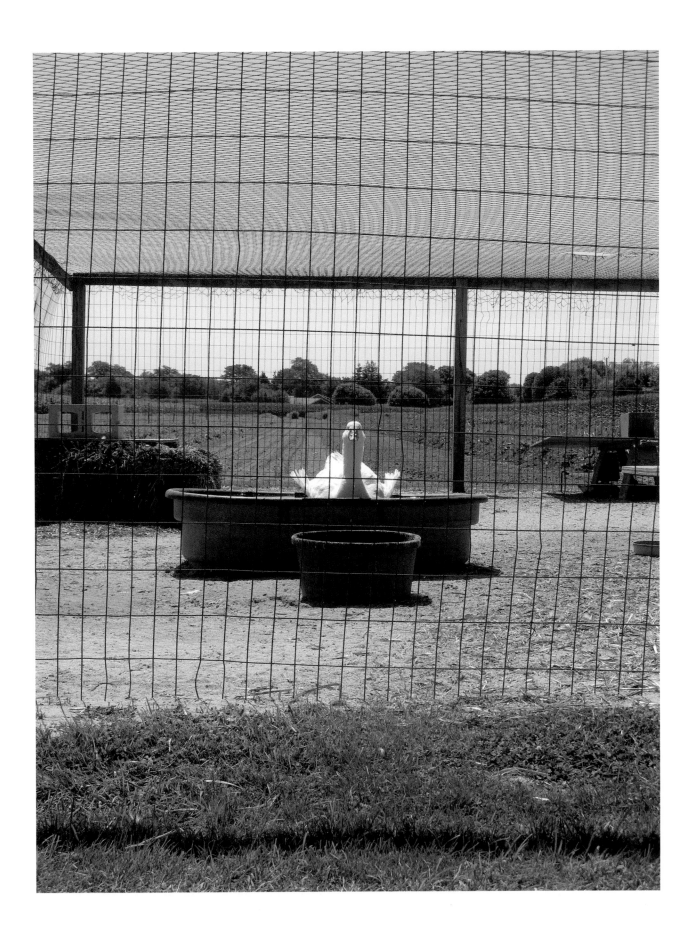

PLATE 13

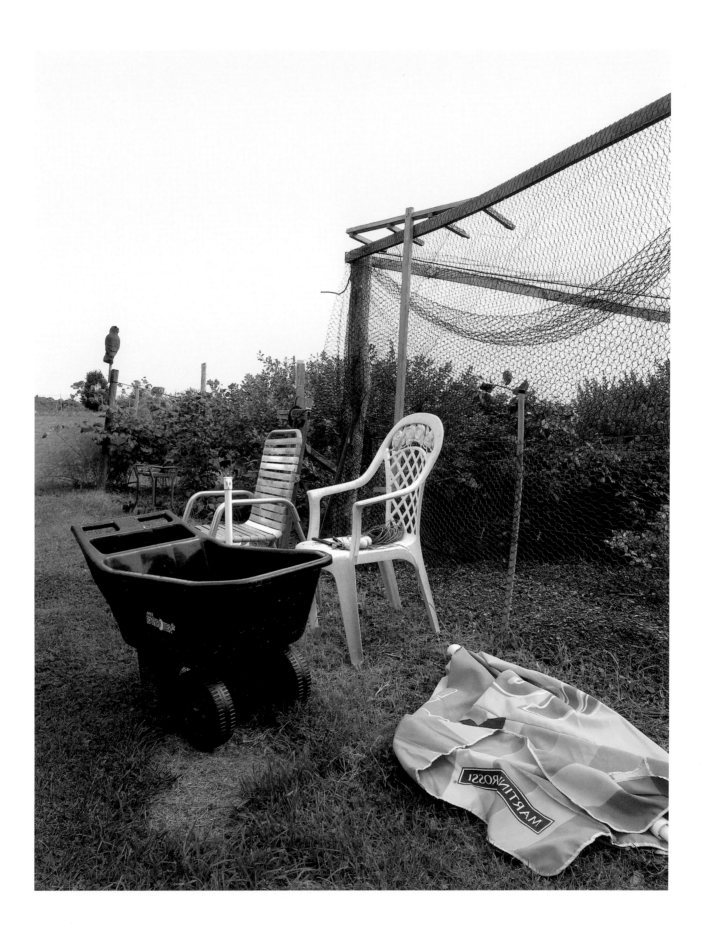

PLATE 14

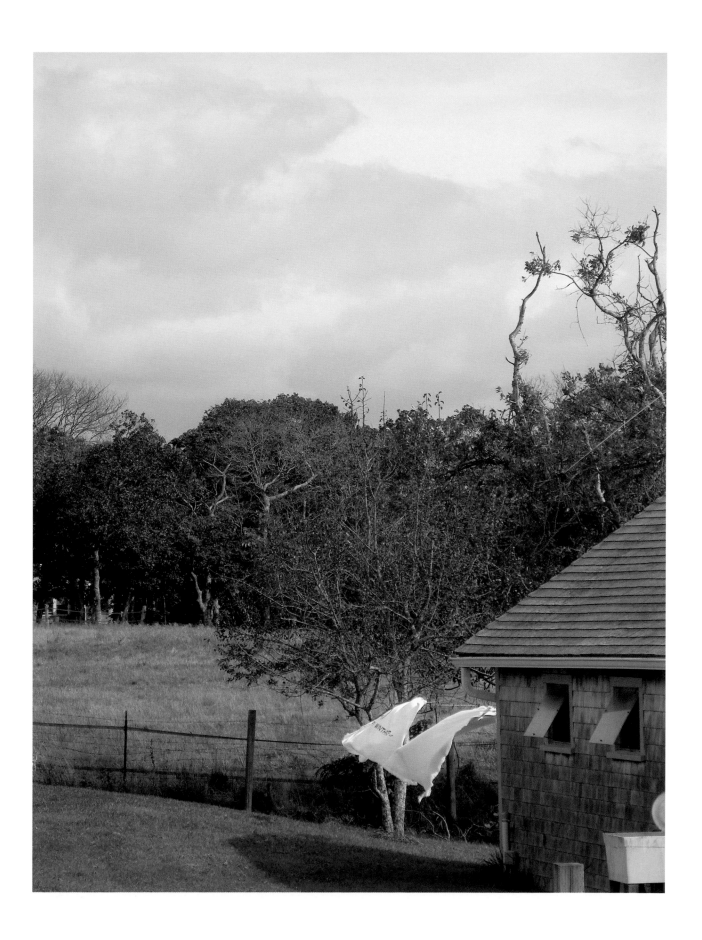

PLATE 15

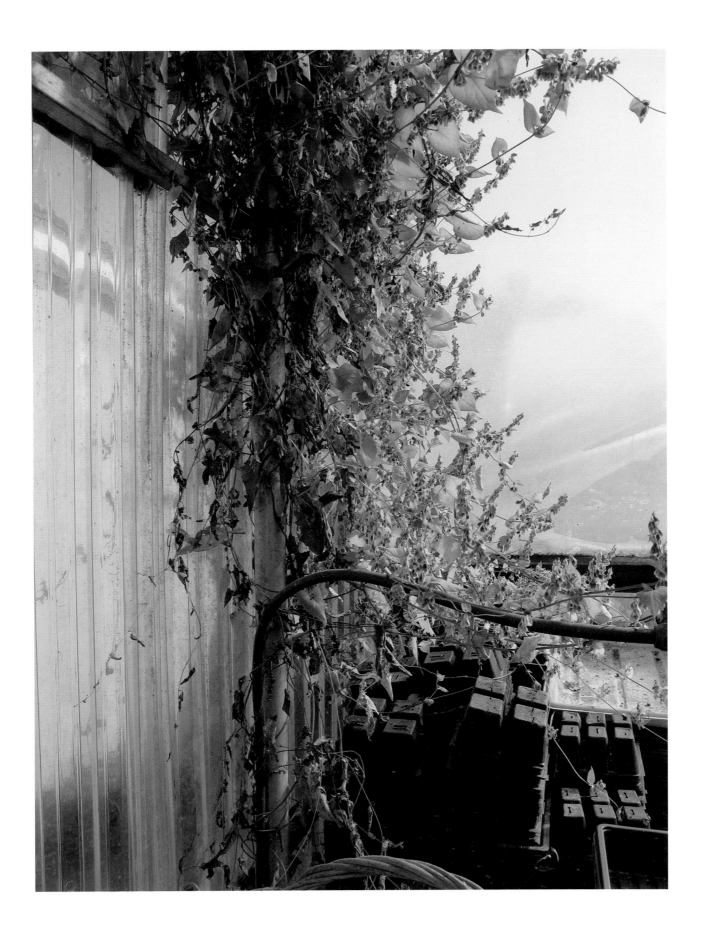

PLATE 16

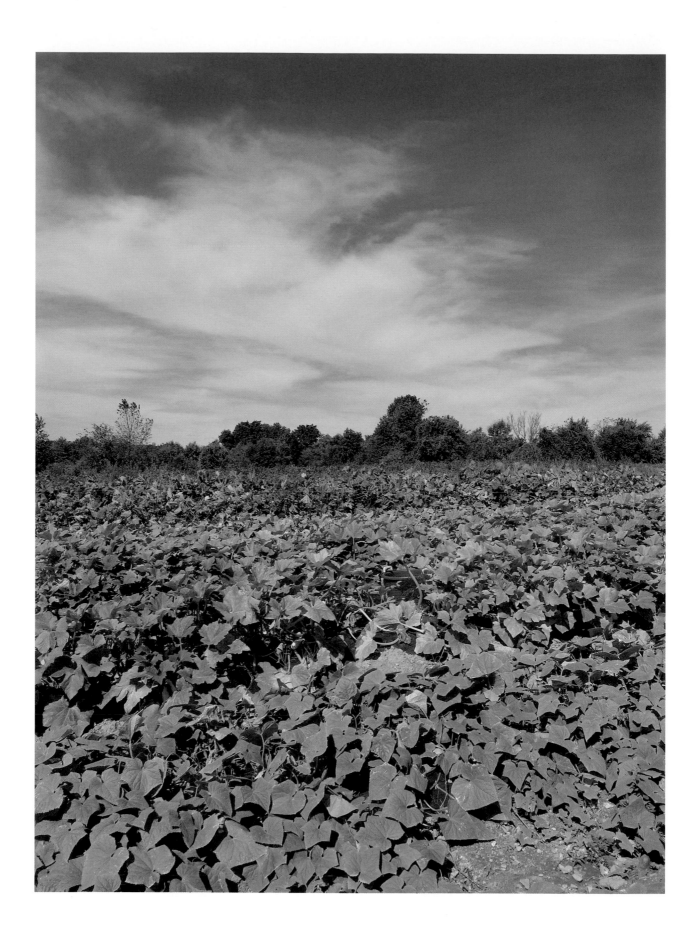

PLATE 17

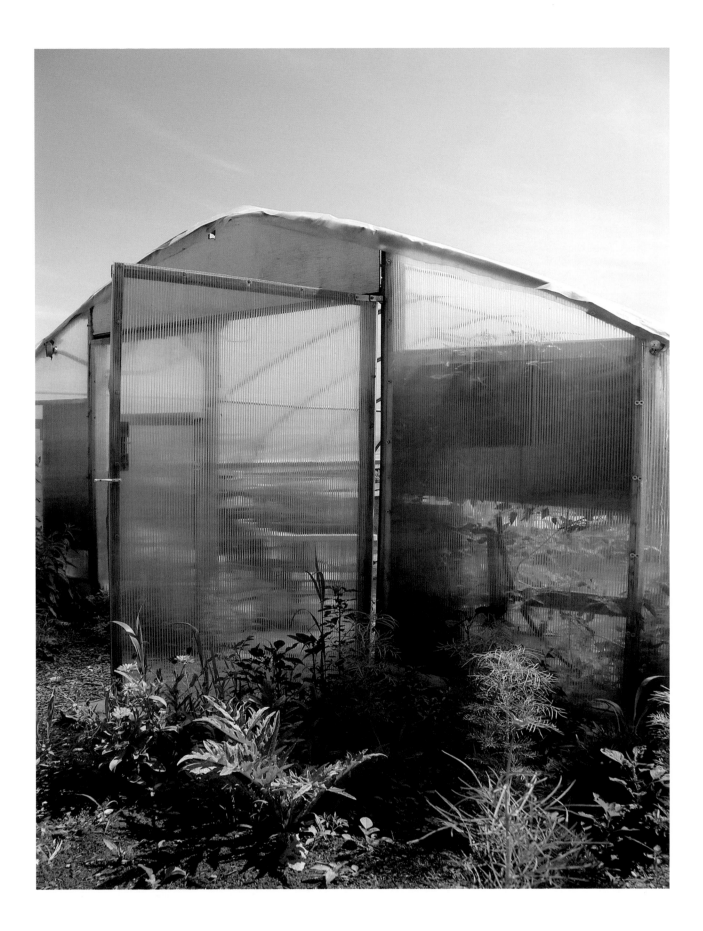

PLATE 18

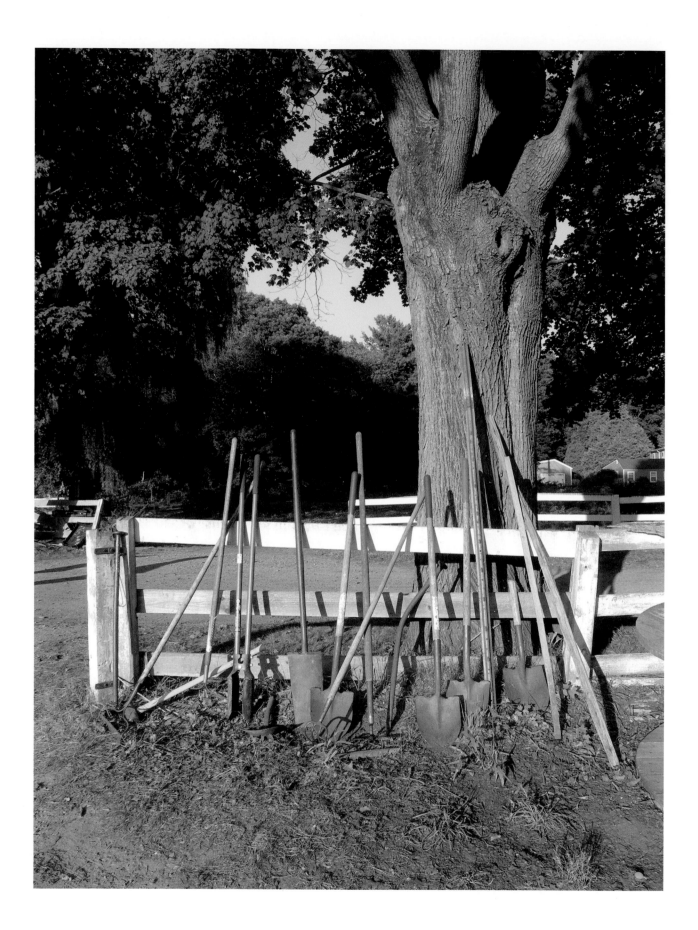

PLATE 19

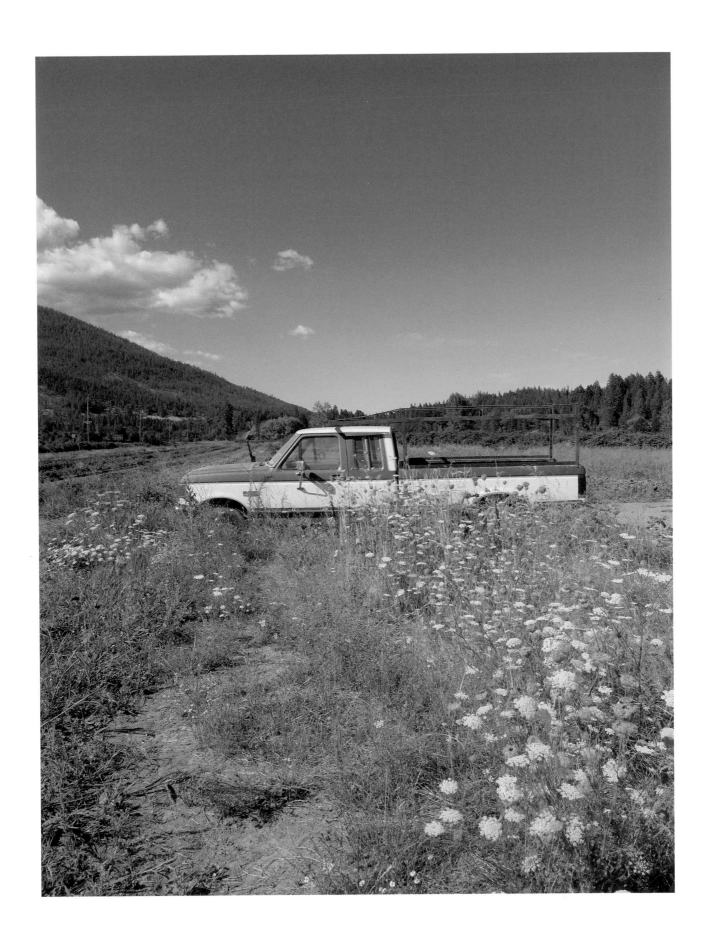

PLATE 20

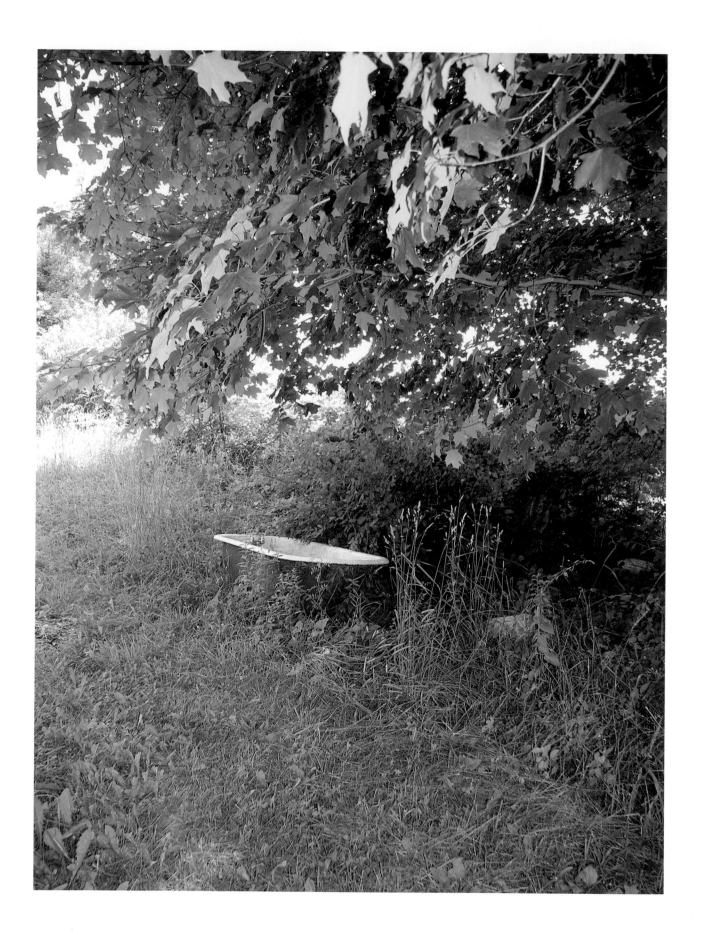

PLATE 21

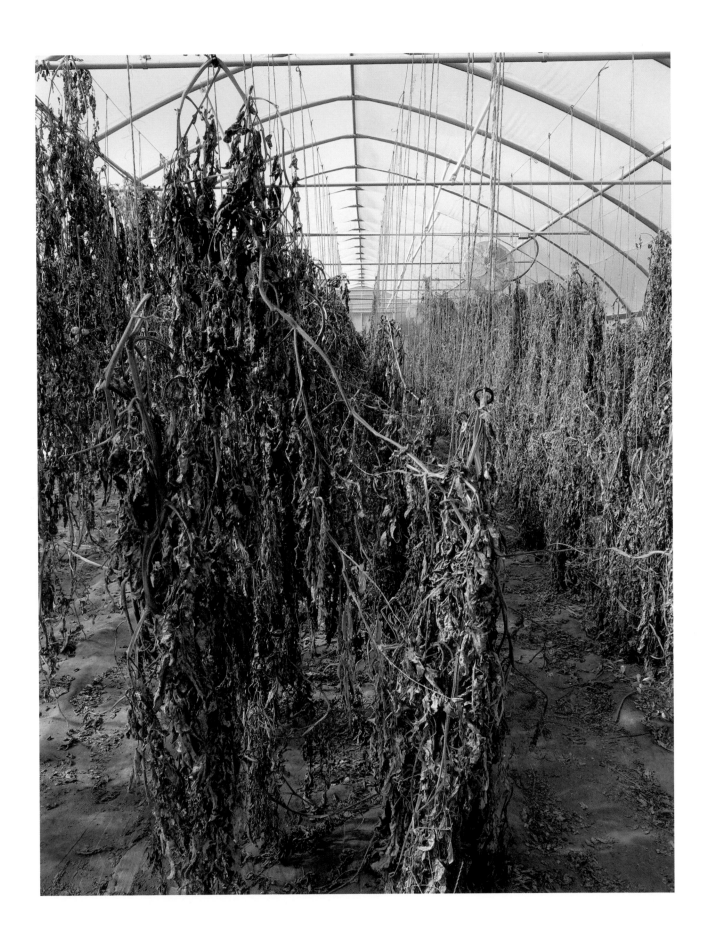

PLATE 22

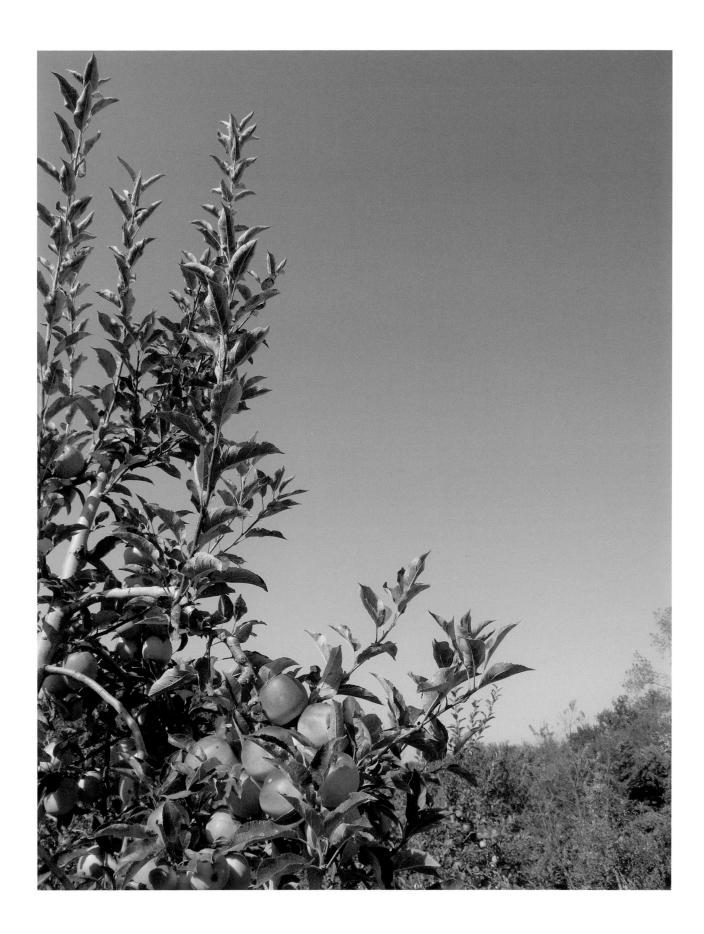

PLATE 23

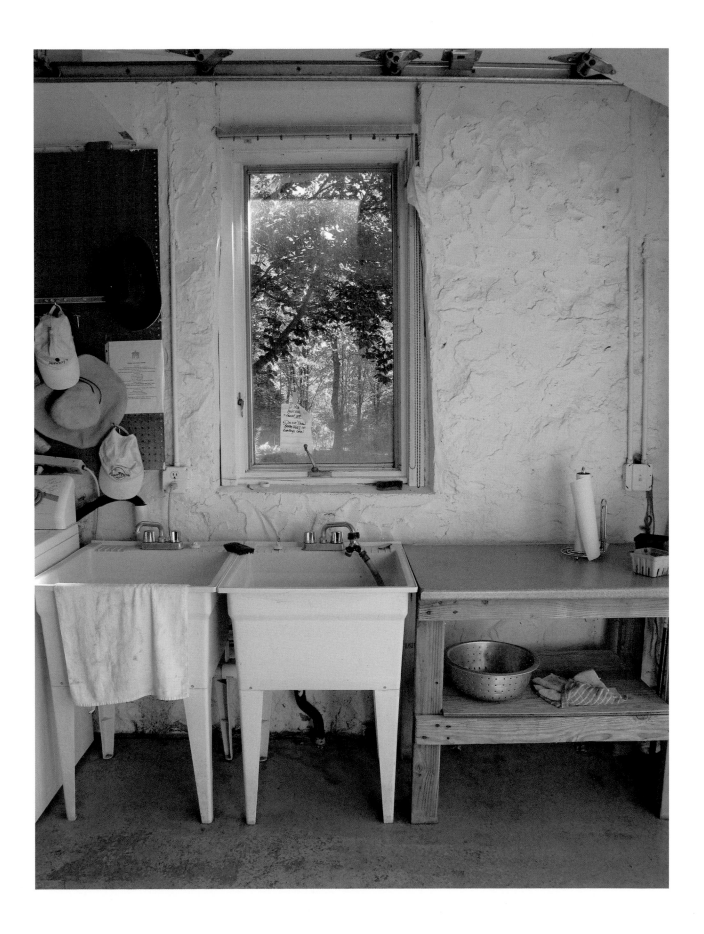

PLATE 24

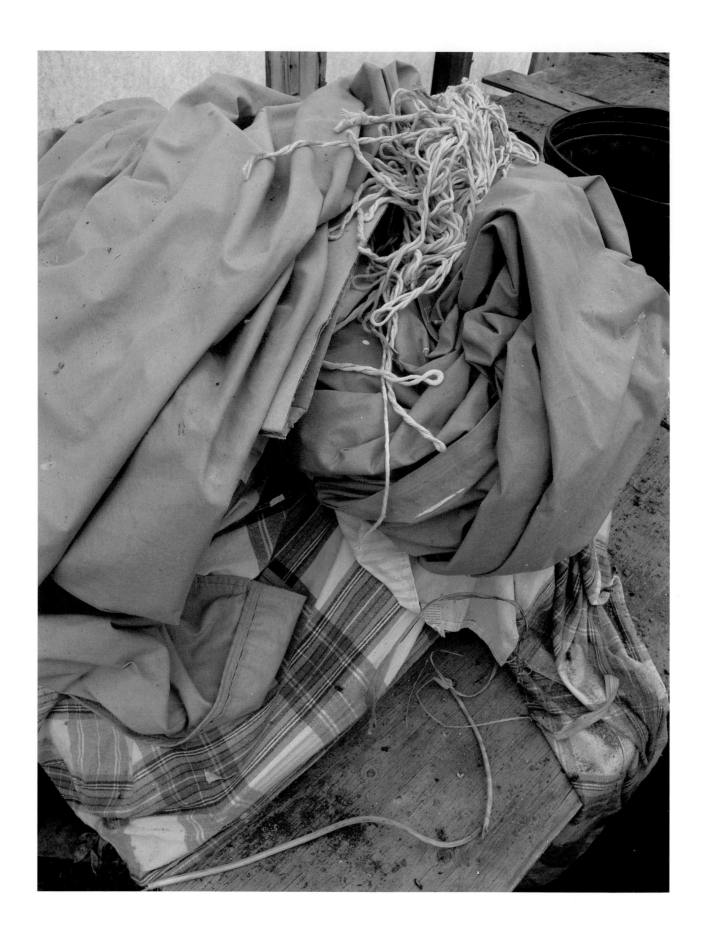

PLATE 25

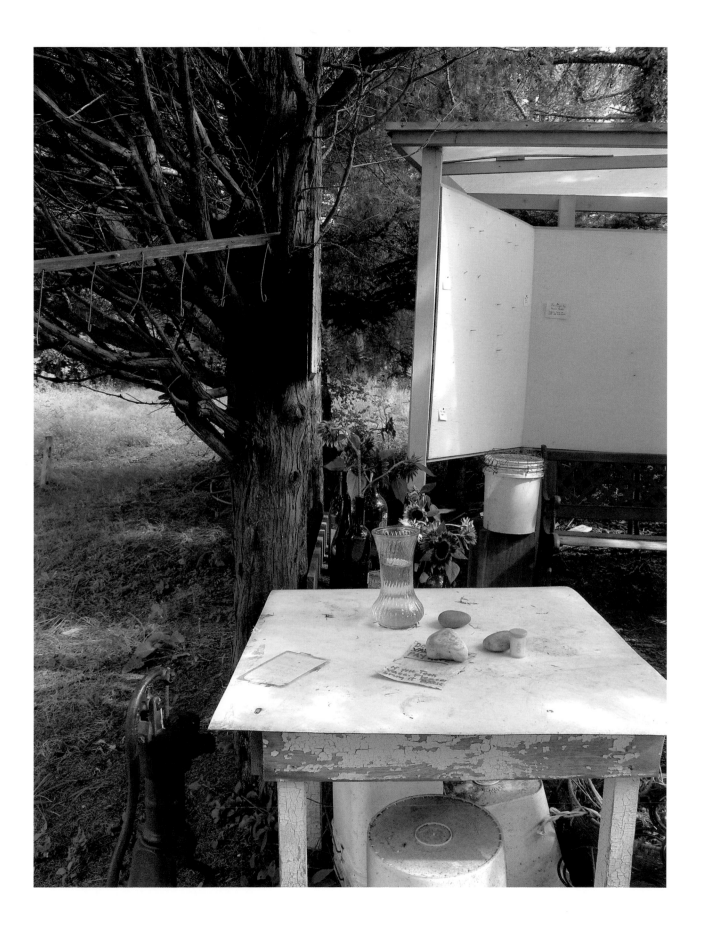

PLATE 26

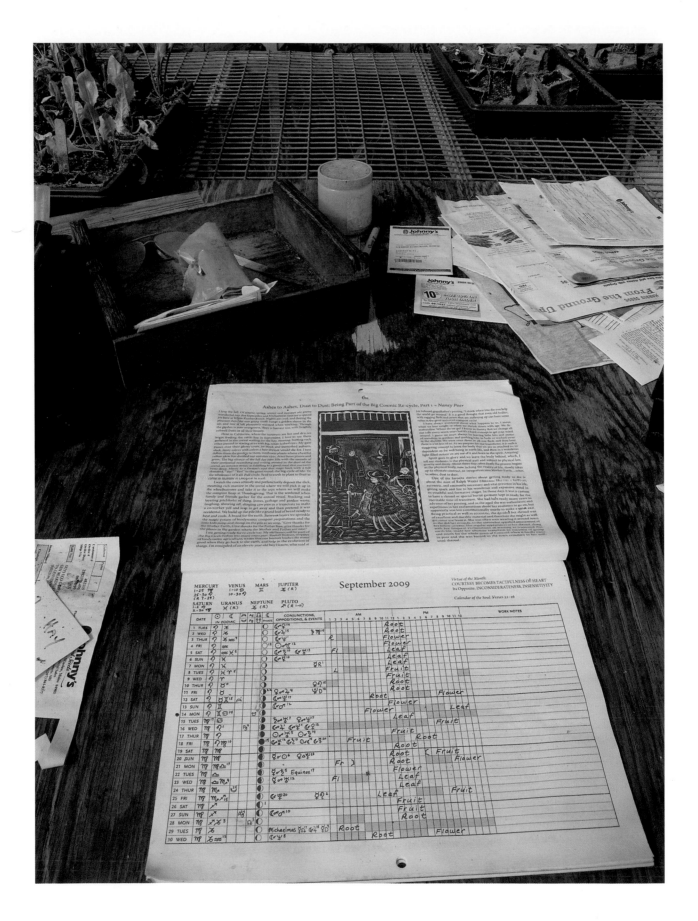

PLATE 27

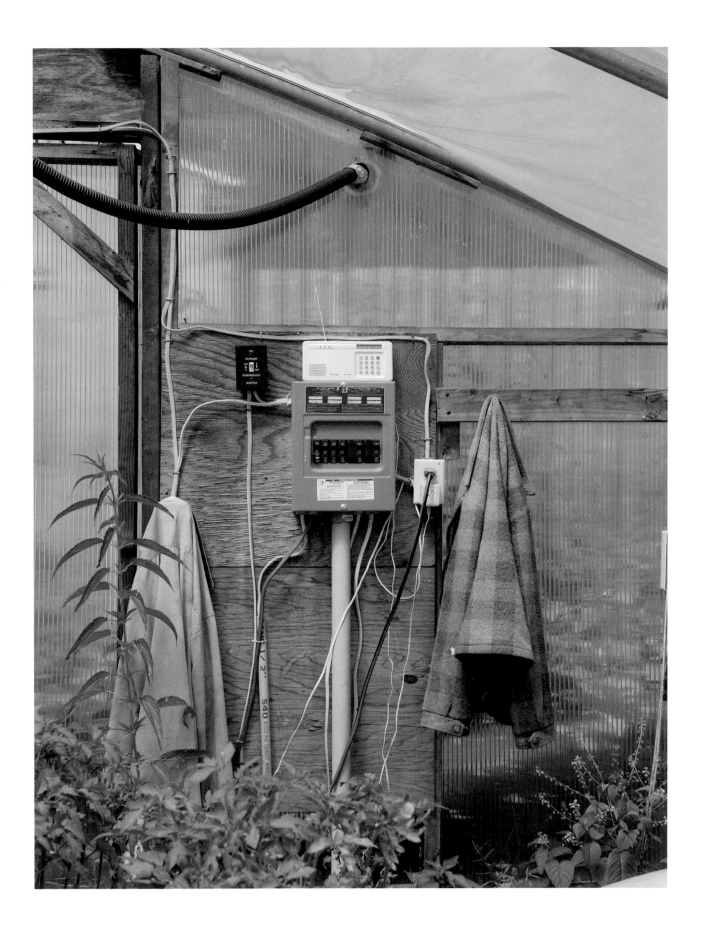

PLATE 28

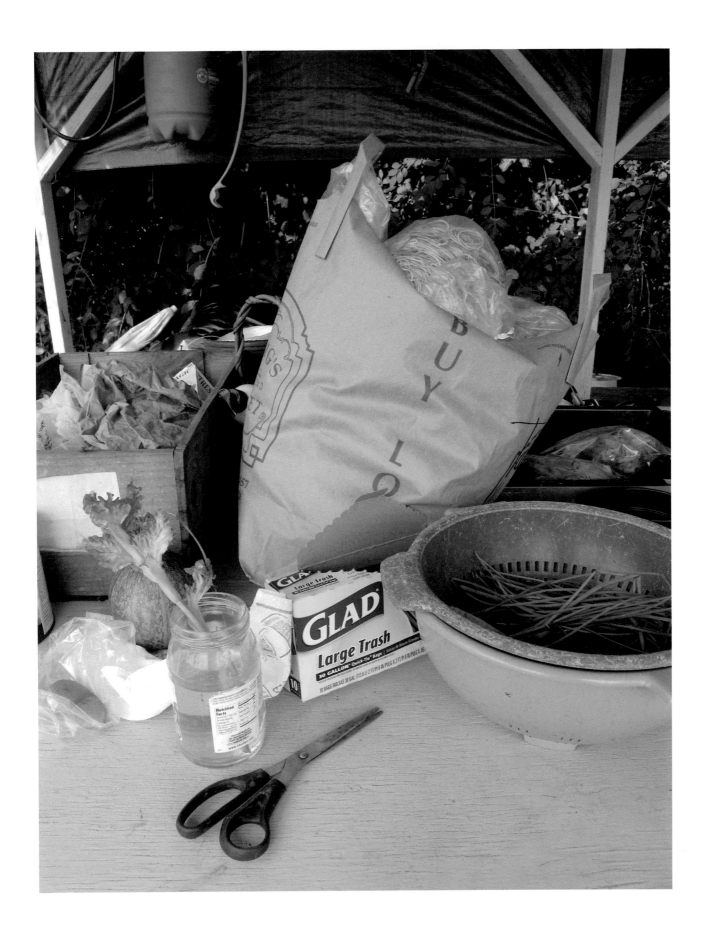

PLATE 29

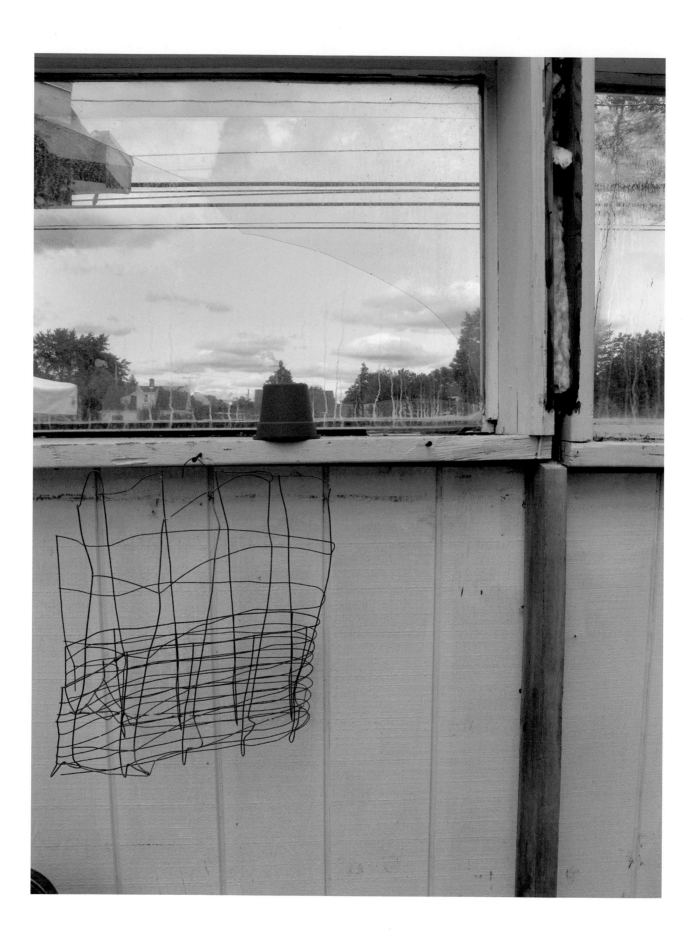

PLATE 30

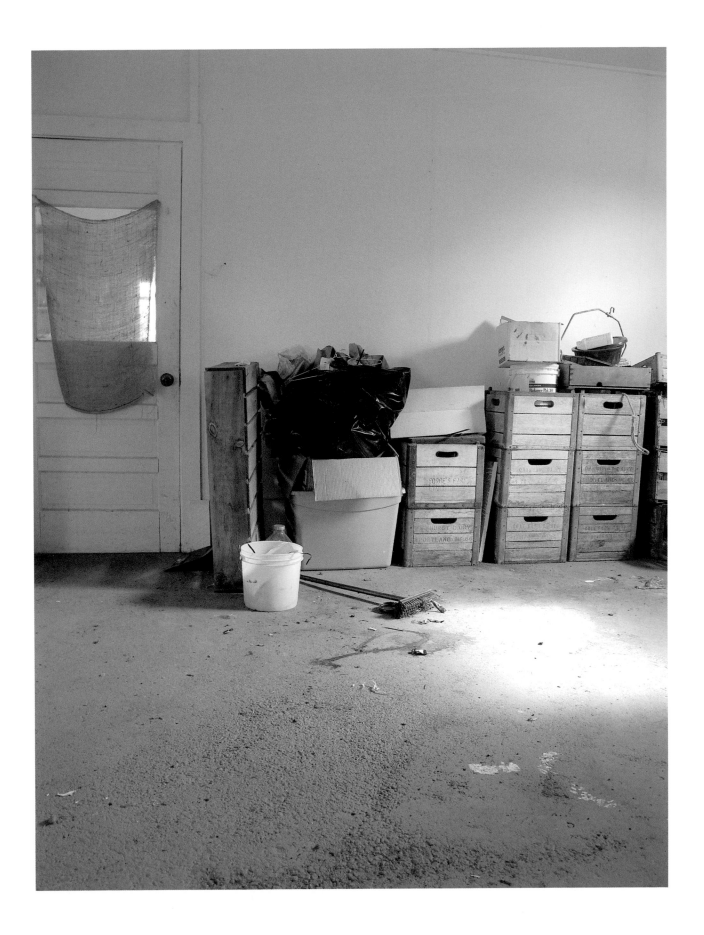

PLATE 31

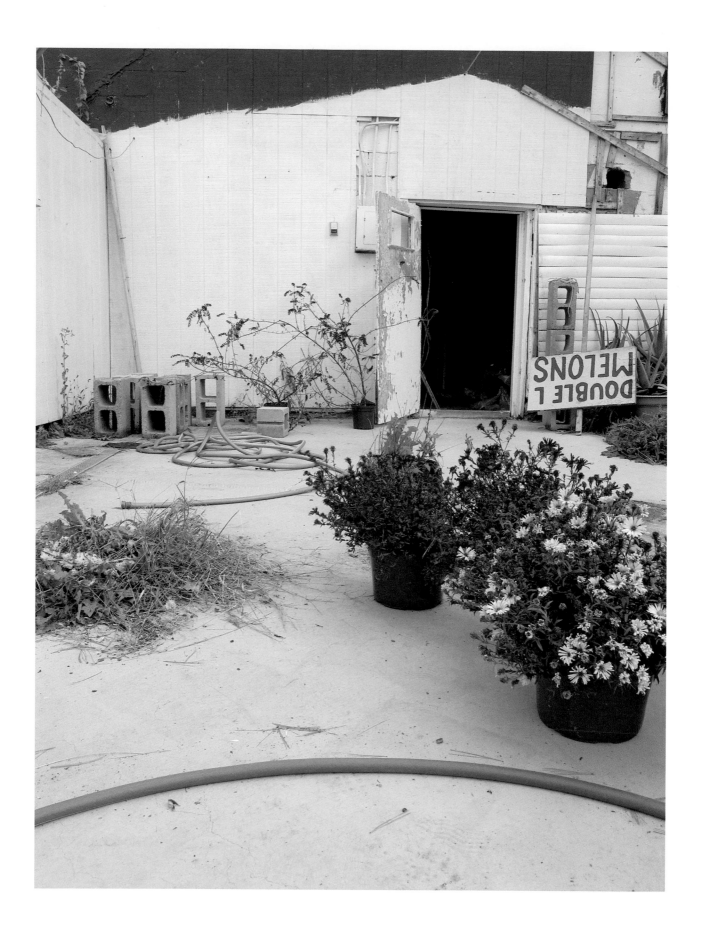

PLATE 32

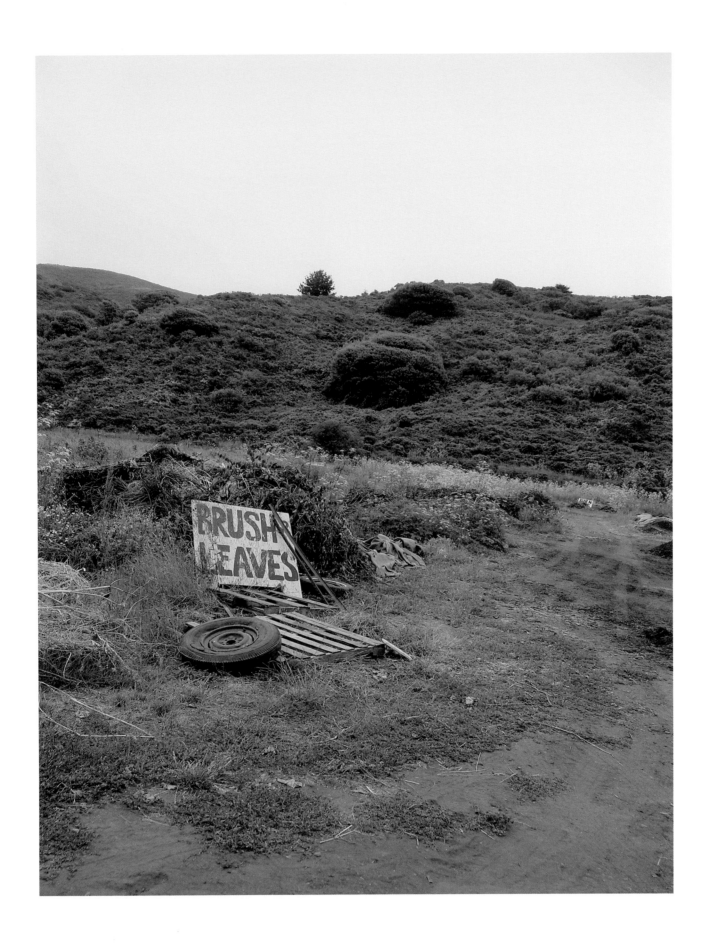

PLATE 33

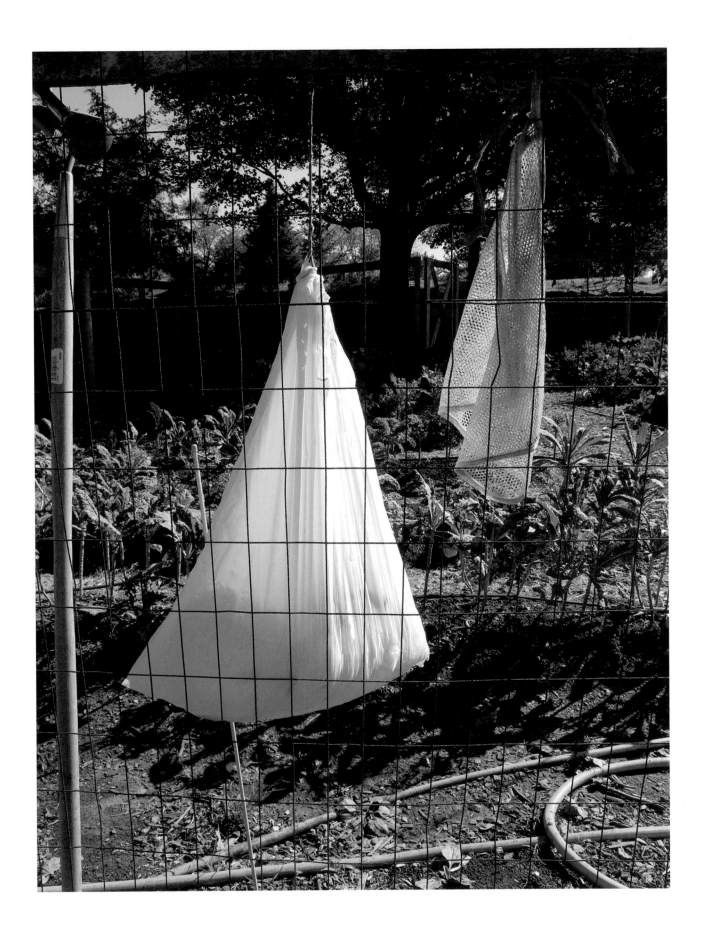

PLATE 34

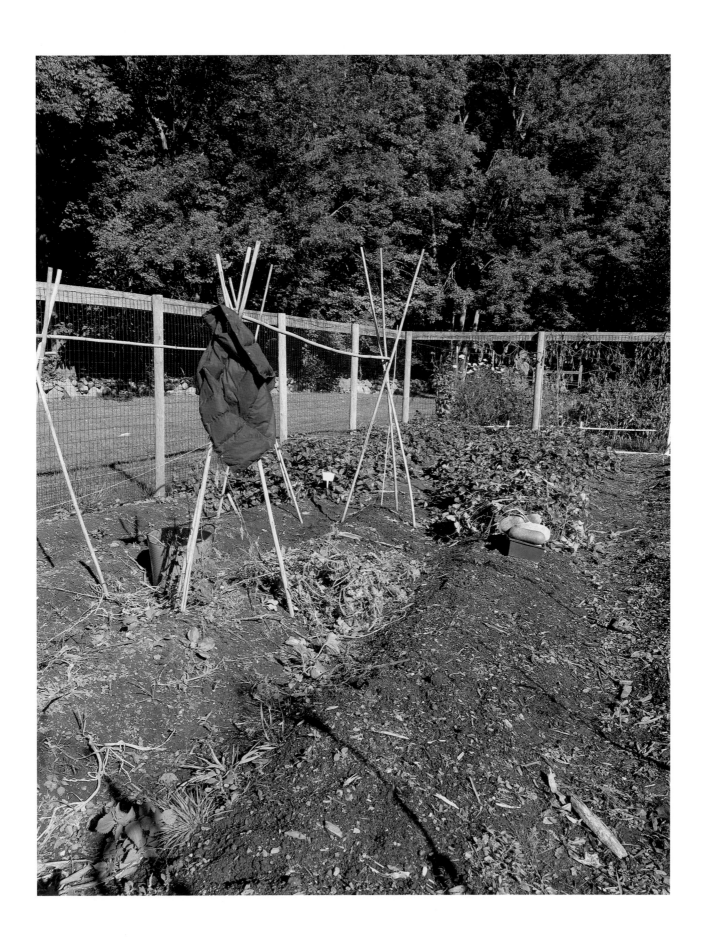

PLATE 35

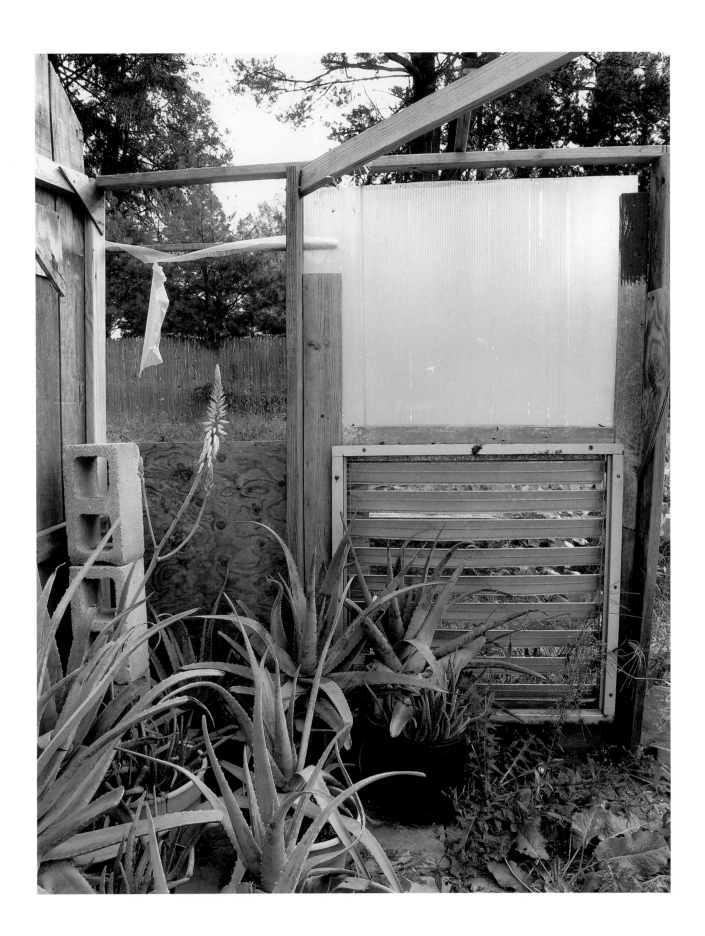

PLATE 36

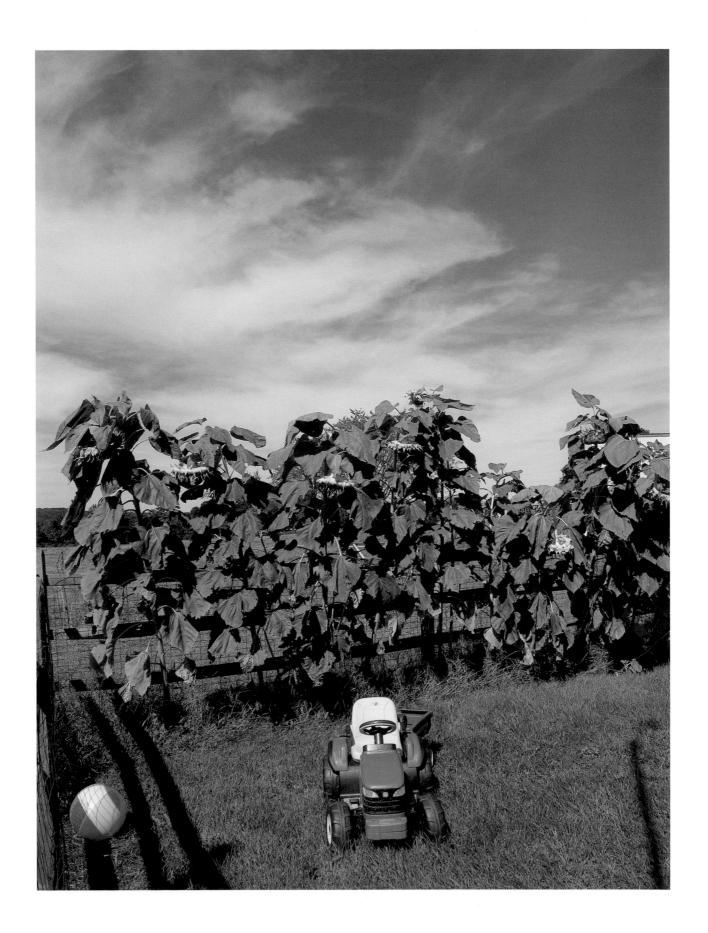

PLATE 37

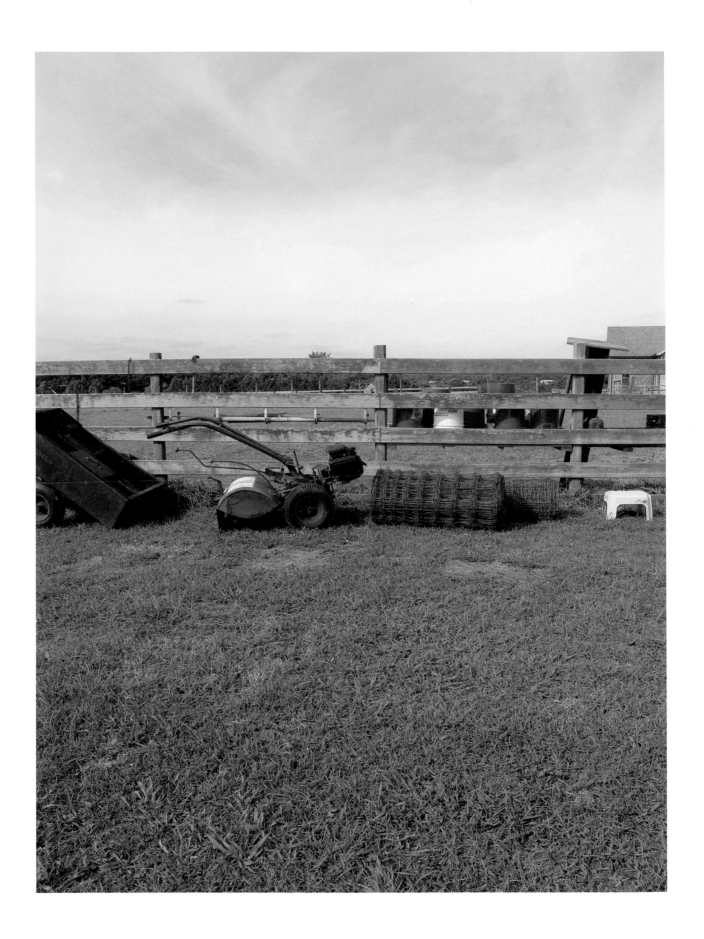

PLATE 38

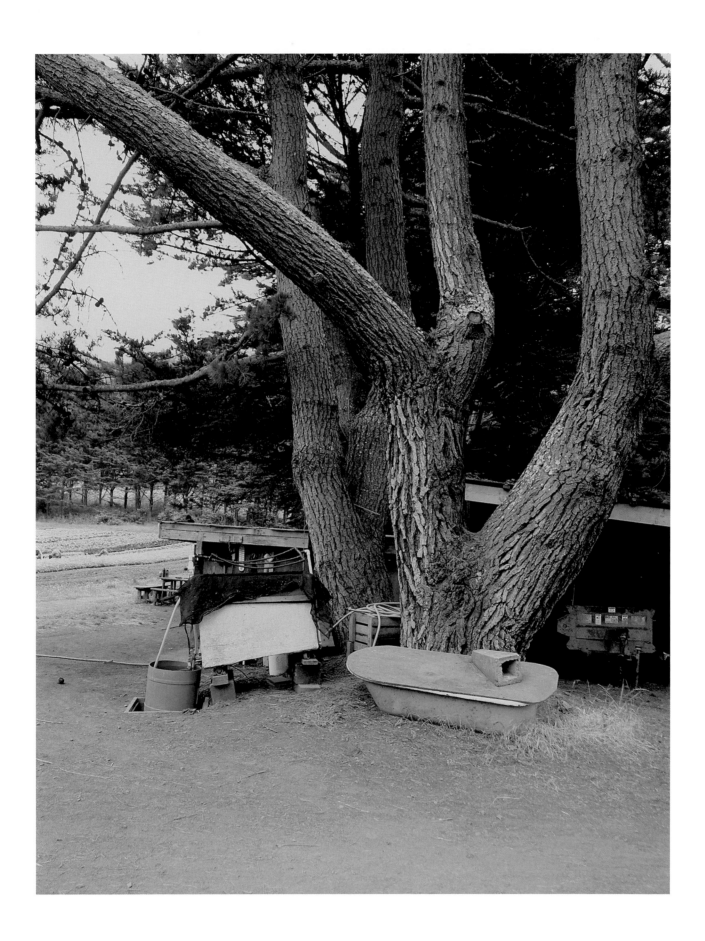

PLATE 39

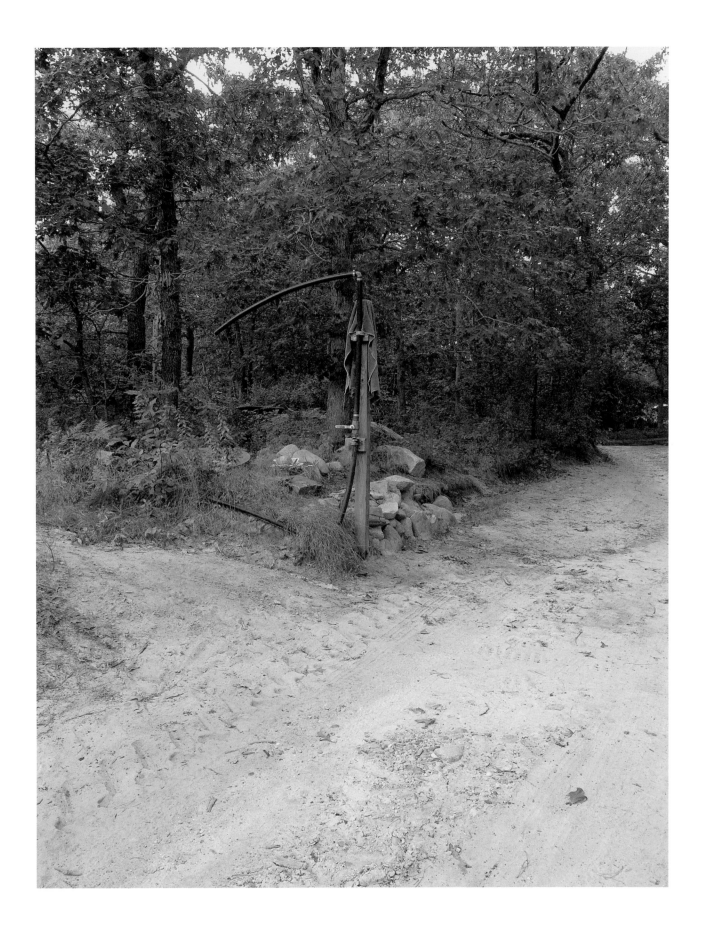

PLATE 40

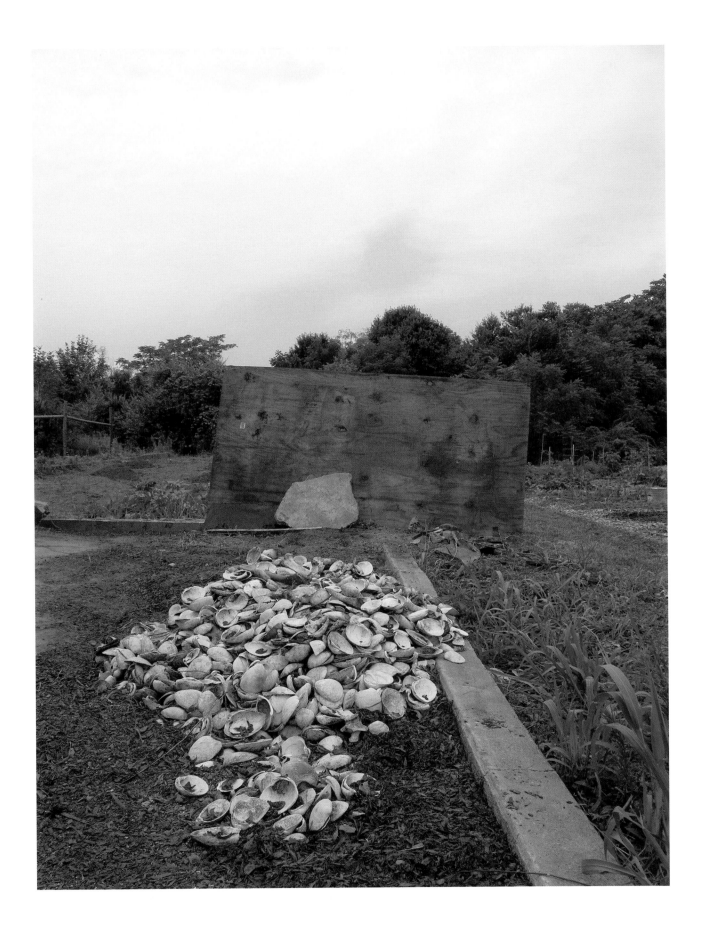

PLATE 41

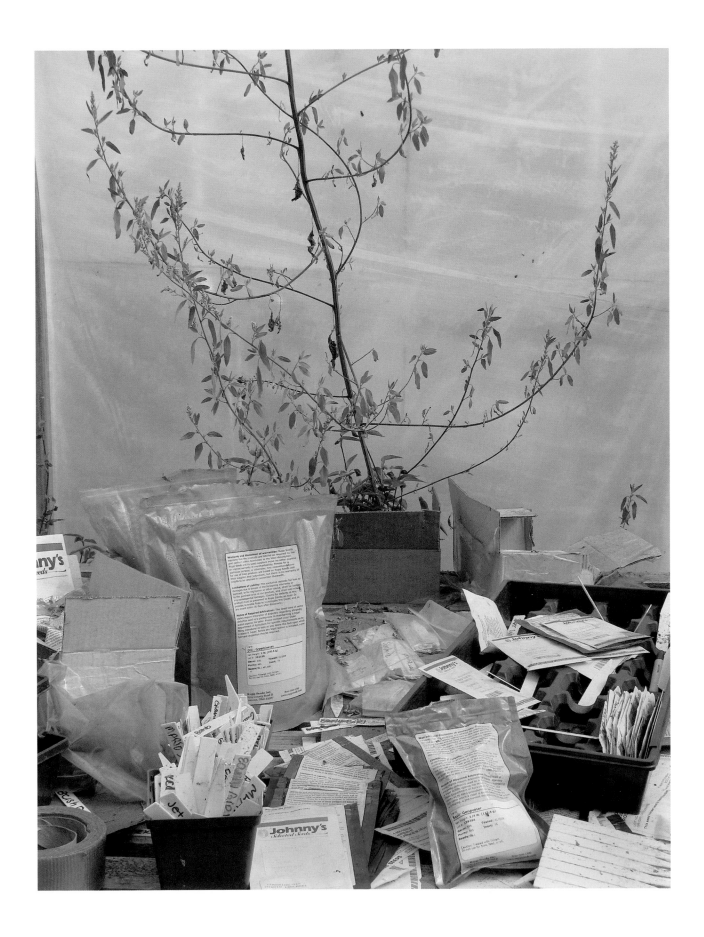

PLATE 42

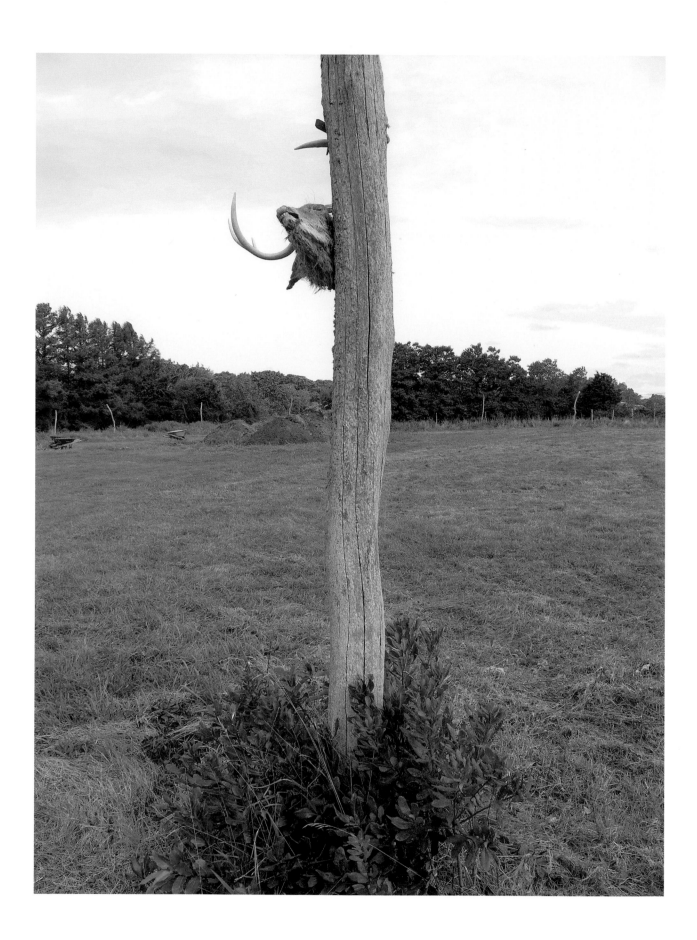

PLATE 43

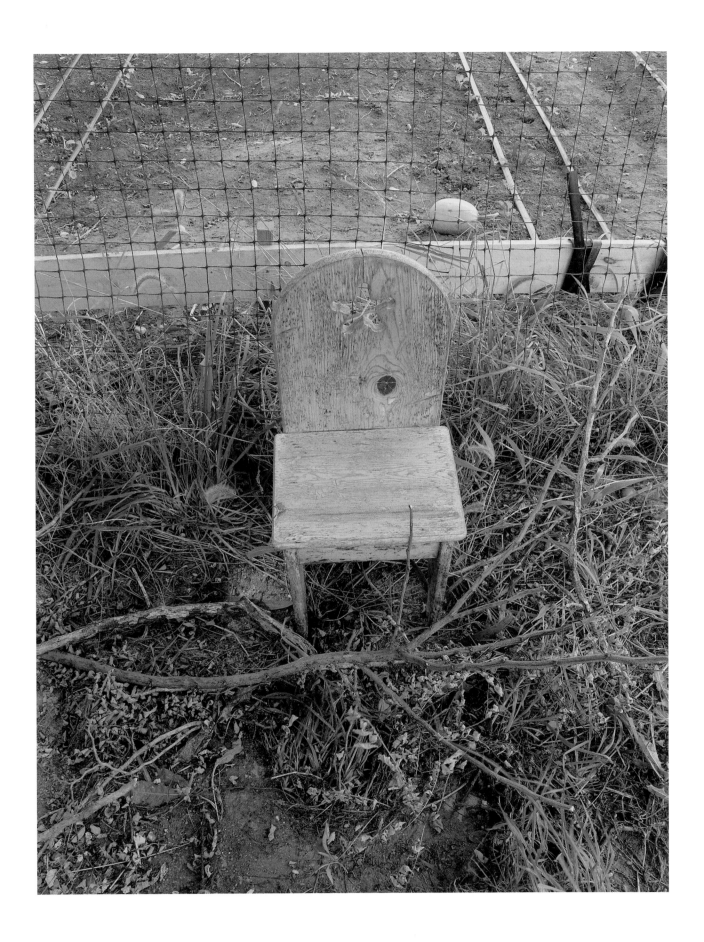

PLATE 44

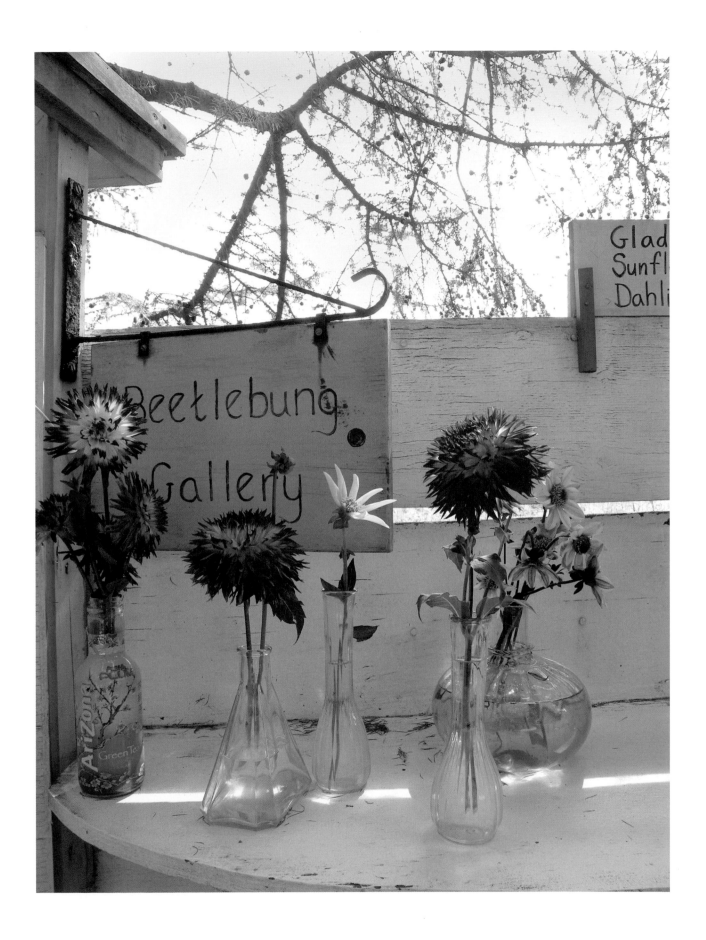

PLATE 45

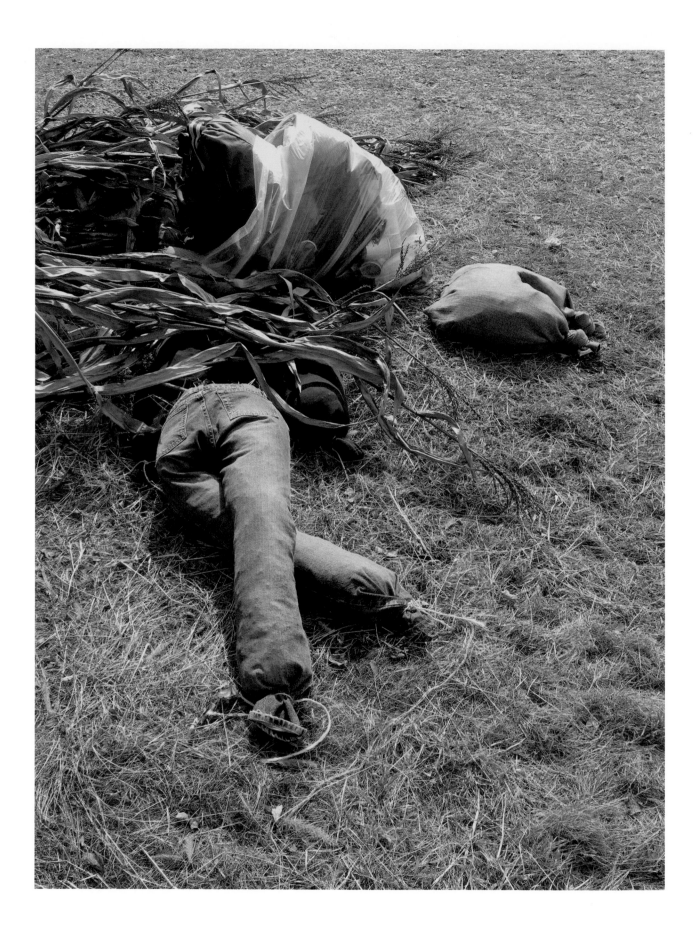

PLATE 46

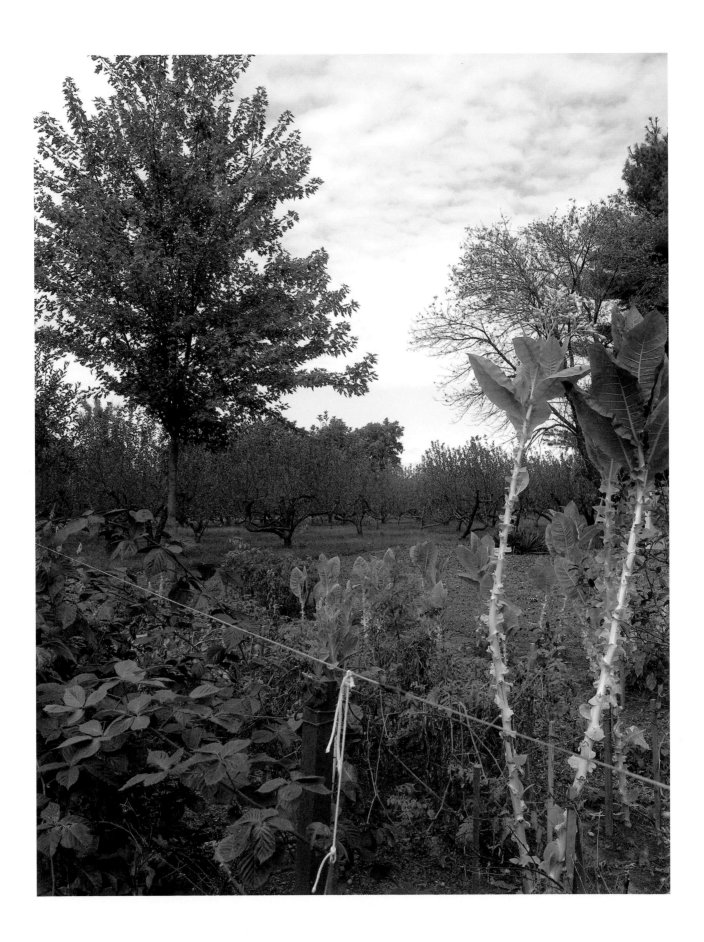

PLATE 47

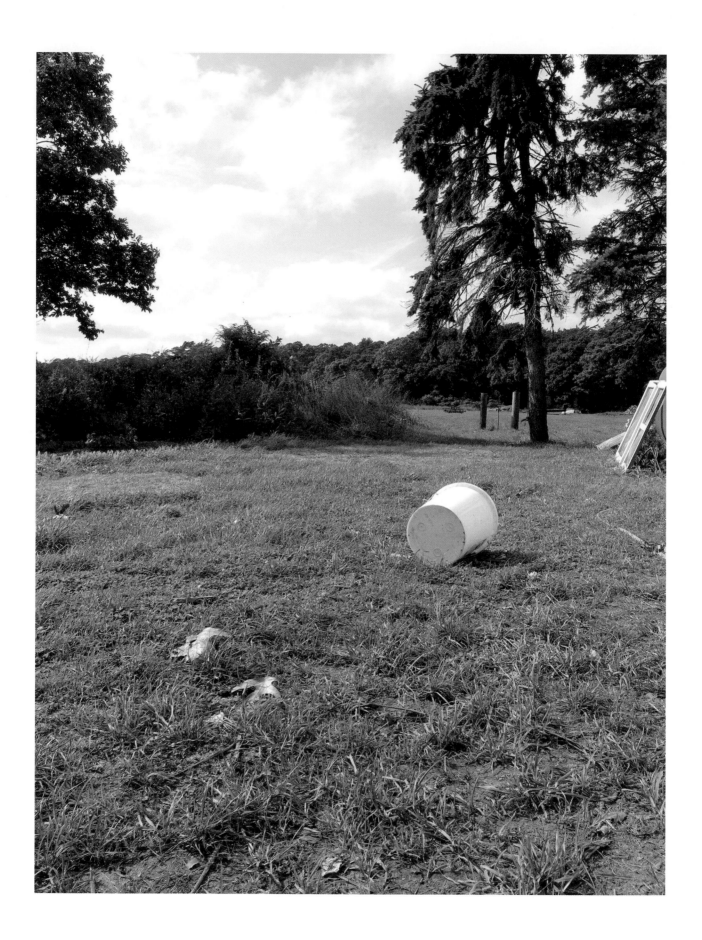

PLATE 48

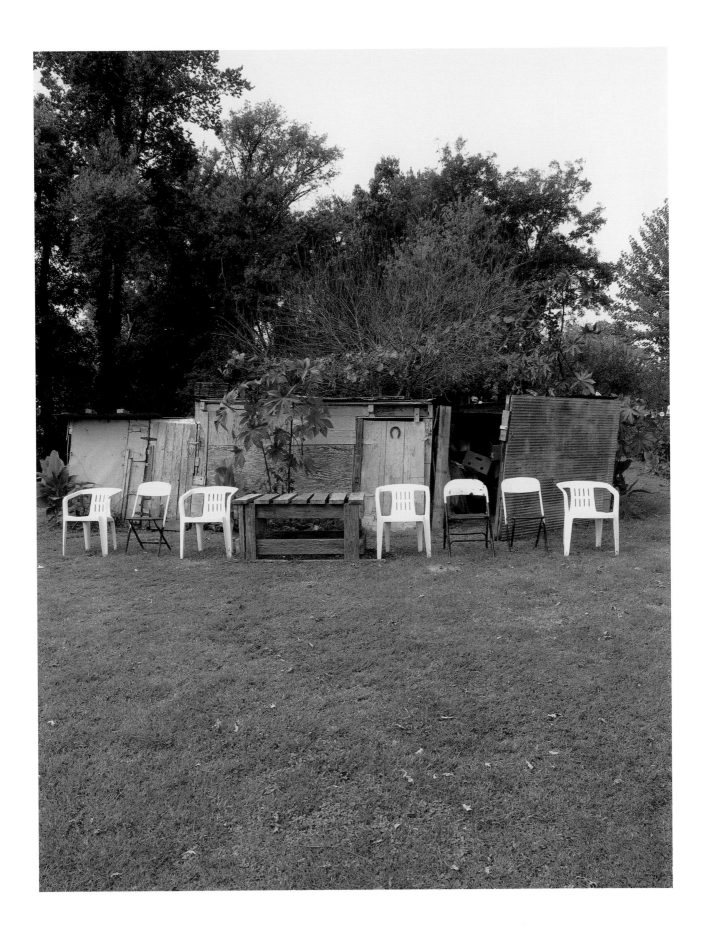

PLATE 49

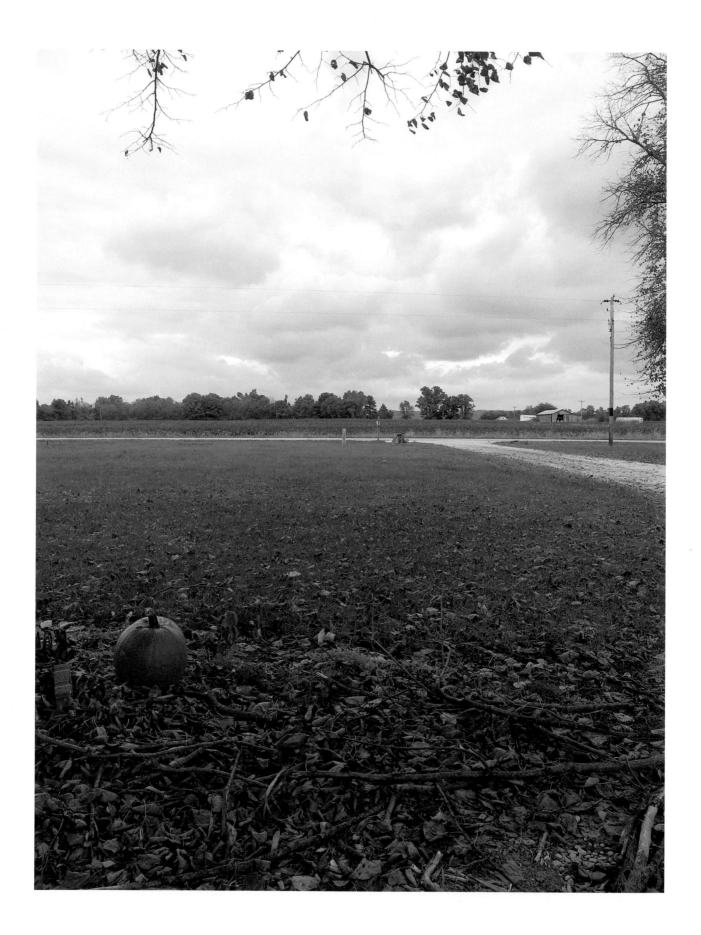

PLATE 50

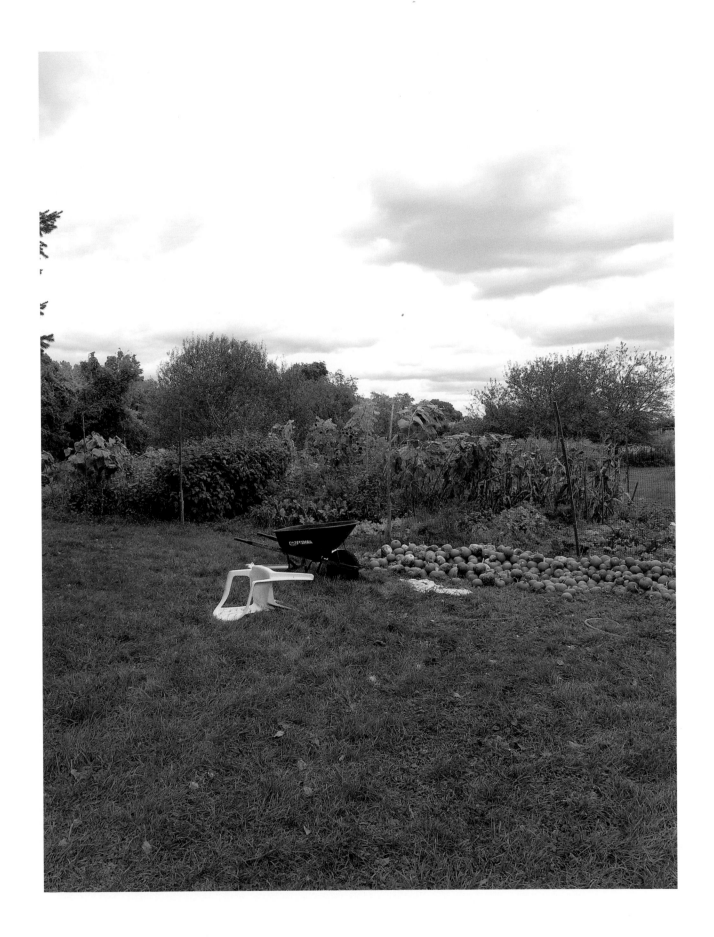

PLATE 51

For the past couple of years, I have planted a small garden in the backyard of my urban apartment. Each year, I try out a new type of vegetable, and each year, one (or more) of the plants does not survive. This summer is no different: my zucchini plant is producing only flowers, and something is gnawing on the jalapeño leaves. To comfort and inspire my dejected green thumb, I pay regular visits to regional farms in search of produce that is freshly picked. I have two favorite haunts, each just a few miles out Route 2 past Walden, the pond that was Henry David Thoreau's muse and an icon that has inspired generations of Americans to consider the land.

My local farms, both passed down through generations, are not unlike those that Sandi Haber Fifield explores in this volume. Captured over two growing seasons, the images in *Between Planting and Picking* depict over a dozen small and family-run farms ranging from the West Coast to the Northeast. This, however, is not a guidebook to environmentally conscious farms of North America, nor is it meant to be. Parting the curtain, Haber Fifield allows viewers to witness what customers normally do not experience at the farm stand or grocers. Along the way, we encounter intimate moments of specificity, stillness, and splendor. Haber Fifield's previous book, *Walking through the World*, took readers on a poetic, photographic journey; this work explores by lingering, not moving on, and builds a complex vocabulary of visual association. It is photography as a form of planting. Every snap of the shutter deposits a new vision into the world, each with the infinite potential to grow in the minds of others.

Between the planting and picking of the title, of course, comes tending and watering, weeding and pruning, living and growing, reaping and dying. There is something about the lexicon of farming that lends itself to poetry and metaphor. Germinating, ripening, harvesting—we could not express ourselves as well without words like these and the elemental, essential, and timeless cycles they represent. In her photographs, Haber Fifield aims for that which eludes ordinary description in order to convey what she calls "the reality of, the feeling of, the land." Her gaze pauses on the simple things: the quality of light as it filters through a greenhouse wall or the accidental beauty of boxes heaped high in a corner. In doing so, Haber Fifield encourages us to ponder a rich middle ground: what happens in the time and space before the produce arrives at the stand and on our tables.

Haber Fifield's artwork and approach also exist in an intriguing in-between. If we were to attempt to categorize her genre, we might assign it to landscape or still life. Yet, these labels are incomplete. She shares company with early color photographers who focused on the vernacular and celebrated the ordinary, but her tendencies also align with painting from even earlier eras. Picturesque landscapes, for example, celebrated the ruined, the overgrown, and the irregular; Haber Fifield is drawn to the edges of scenes, the space where weeds lurk and things pile up. Reminiscent of still-life painting in which a piece of fruit symbolizes the fecundity of nature while hinting at its eventual decay, her pictures allow for psychological projection. But rather than presenting us with traditional arrangements, she finds and offers images of mundane materials, such as wire mesh or plastic bags, which through her lens become luminous and otherworldly.

There is a distinct architecture to Haber Fifield's imagery. How she structures her compositions parallels how we craft, shape, and work the land. Once at these farms and within the fields, Haber Fifield surveys the settings, looking for and reacting to environmental connections and visual links. Flipping through the pages of *Between Planting and Picking*, we notice a rhythm and the coming together of individual images into a whole. Within the sequence, viewpoints alternate between inside and outside, near and far. Gradually, we realize that materials, shapes, and colors subtly repeat. Red, for example, shows up again and again – in a glass orb, chopped up rhubarb, or cloth hung on a pole – mirroring the Hudson River School painters' use of this hue to point to human presence within the landscape.

Haber Fifield frequently pairs order with disorder in her compositions. This is not unlike farming itself. We attempt to control nature just as hard as it denies our jurisdiction. An underlying geometry of wiring, netting, and fencing also appear throughout the pages of *Between Planting and Picking*. At the same time, various items and vegetation bend and veer off in other directions. In one photograph, for example, the bottom half is defined by a systematic grid of metal fencing, while the top half dissolves into wildly curving tendrils of new growth. In another, disarray is coupled with organization: amidst a cluttered pile of seed packets, labels scribbled with plant names await their eventual association.

Certainly, photography and farming can involve a lot of elaborate tools. A visit to any garden or camera store confirms this. Yet, at their most basic levels, the two practices do not require many accessories, and their practitioners often have a thrifty fondness for the makeshift. A modified coffee container can be made into a camera or a chair into a tripod, just as a rag is able to train a vine. Indeed, to produce her early work, Haber Fifield regularly altered the inner workings of her cameras. A similar creative practicality permeates the farmers' jerry-built efforts. Tables and sheds are cobbled together, and milk crates and buckets serve several functions. Such found assemblages, Haber Fifield explains, represented "the still life that kept growing in my head" in which "ultimately, the goal is to cultivate the land and get the job done."

In Haber Fifield's photographs, objects take on personalities and appear to arrange and re-arrange themselves: hoses and buckets misbehave and wander off, sunflowers bow their heads to a toy tractor, a row of white chairs stand at attention, and a lone pumpkin yearns to be with the rest of the patch. And although people are nearly absent—appearing only once, and then only in the distance—her images could be read as portraits, too. Farmers and field hands seem to have just departed after a day's work, leaving behind scattered clues as to their states of mind. Seeking out the tranquil moments between periods of intense activity, Haber Fifield observes that farmers spend the majority of their time alone, lost in thought. As viewers, we get to know these laborers from their land and the evidence of their work upon it.

Haber Fifield was initially inspired to undertake this project by a visit to Green Gulch, a pioneering organic farming community located within the San Francisco Zen Center. The unity of land, process, and people was palpable to her there: "As an observer, I could sense a direct connection between the Zazen practice and what was happening in the fields." Sustained looking, even what she has described as "sublime waiting," is felt throughout *Between Planting and Picking*. It amounts to a patient but powerful presence, a Buddhist-like quality of being-there-ness, and contributes to a distinct sense of place. It's as if Haber Fifield is urging viewers not simply to look, but to look *here*.

Natural forces and cycles are present, too, both of land and life. In *Between Planting and Picking*, seasons surface and fade. Blooming flowers call to mind the bounty of spring, while withered tomato plants and a cast-off scarecrow foreshadow fall and the dormancy of winter. One image bookends existence for man and plant: a field of matted corn stalks leads our eyes to a small cemetery, presumably the family plot of those who live in the farmhouse beyond. Dust to dust, life returns to the earth it tended. In another picture, a tidy timetable lies open on a messy desk. Amid piles of paperwork, phases of the moon and plants are brought together in grid and graph, one column repeating words like a mantra: root, leaf, flower, fruit, root, leaf, flower, fruit.

When it comes time to pick from my own tiny garden, I proudly photograph the first tomato before I eat it. I know more after one season than I did before: I have learned that a zucchini plant needs a mate to yield vegetables and a mixture of red pepper and oil will keep nibbling intruders at bay. In this time between planting and picking, I have grown, too. I think that must be why I find such comfort and pleasure in Haber Fifield's photographs; they make me keenly aware of place and of the origins of my food. But inspired by Sandi Haber Fifield, I now look to the median as well as the margins, hoping to catch a glimpse of the overlooked and the underseen.

PLATES

SANDI HABER FIFIELD has widely exhibited her photographs throughout the United States. She has been included in exhibitions at The Art Institute of Chicago, The Carpenter Center for the Arts, The DeCordova Museum, The Museum of Modern Art, The Museum of Contemporary Photography, The National Museum of Contemporary Art, The Oakland Museum, The Southeast Museum of Photography and The St. Louis Museum in addition to numerous gallery exhibitions. Her work is held in several private and public collections including The Brooklyn Museum, The George Eastman House, The High Museum, Los Angeles County Museum, The Museum of Modern Art and The New Britain Museum. Haber Fifield's photographs have been published in *Fabrications* by Anne Hoy, *Picturing California* by Therese Heyman, *Defining Eye: Women Photographers of the 20th Century* and *The Photography of Invention* by Merry Foresta. *Walking through the World*, her first monograph, was published by Charta in 2009.

LESLIE K. BROWN is an independent curator, scholar, and educator pursuing her Ph.D. in Art History at Boston University. A former curator at the Photographic Resource Center in Boston, she holds an M.A. from the University of Texas at Austin and specializes in the history of photography. Brown has taught at the Art Institute of Boston and the Rhode Island School of Design.

DOMINIQUE BROWNING is a writer, editor and consultant in the newspaper and magazine fields. She writes a monthly column, "Personal Nature" for the Environmental Defense Fund website, and regularly reviews books for the *New York Times Book Review*. Until November 2007, Browning was the editor-in-chief of *House & Garden*; she has worked with and written for *The Wall Street Journal*, *New York* magazine, *O, The Oprah Magazine*, *Travel & Leisure*, *Whole Living*, and *Wired*, among others. Her most recent book is *Slow Love: How I Lost My Job, Put on My Pajamas, and Found Happiness*. She blogs at SlowLoveLife.com

KAREN SALSGIVER is principal of the firm Salsgiver Coveney Associates in Westport, Connecticut, whose award-winning designs have appeared in *Communication Arts, I.D. (International Design), Print, Graphis Branding, Graphis Design Annual, AIGA Graphic Design U.S.A.,* and *AR100*. Her work is included in the collections of the Rare Book and Manuscript Library at Columbia University, the Rare Book Room of Sterling Library at Yale University, and in the archives of the American Institute of Graphic Arts (AIGA)

The farms photographed for this book are owned and cared for by families, some for many generations. Each farm reflects a commitment to working the land and each family has created an essential place within their community. All of the farmers generously welcomed me; for this, I am deeply grateful.

My immense gratitude to Leslie K. Brown for your poignant essay and scholarly perspective. Leslie would like to thank Thomas Gearty and Bruce Myren for their keen eyes and support.

To Dominique Browning, for an eloquent introduction. Your work has helped reshape the rhythm of our collective lives.

A long and endless thank you to Karen Salsgiver; friend, gifted designer, and trusted advisor on all things visual.

My gratitude extends to several others:

Francesca Sorace and Giuseppe Liverani (and to everyone at Charta), for embracing this project with uncompromising care.

Alice Rose George, for your perfect editing and sequencing.

John Hafey, cherished master printer and technical guide.

Josh Viertel, for your support on behalf of Slow Food USA.

John Willis, my appreciation (long overdue) for first placing a camera in my hand.

Arlette Kayafas, Olivia Lahs Gonzales, Jacquie Littlejohn, Kathy Mc Carver Root and Rick Wester, for generously showing my work, and to Dan Cooney and Julie Saul for your continued support.

For their help along the way, my heartfelt thanks to: Shawna Barrett, Pam Beck, Casey and Chuck Berg, Elizabeth Eisenhauer, George Fifield, Jane Green, Bryna Haber, Jay Haber, Julie Horowitz, Judy Hottensen, Becky Howe, Flora Lazar, Tom O'Connor, Frances Palmer, Chari Polley, Eric Safyan, Amy Simon, Eileen Wiseman, and Jeany Wolf.

Finally, my family, Ben and Jocie, my inspiration and daily reminder that this beautiful earth is to be shared with future generations. And of course, my husband John, who grounds me in all seasons.

Design
Salsgiver Coveney Associates Inc.

Design Coordination
Daniela Meda

Editorial Coordination
Filomena Moscatelli

Copyediting
Sylvia Adrian Notini

Copywriting and Press Office
Silvia Palombi Arte&Mostre, Milano

US Editorial Director
Francesca Sorace

Promotion and Web
Monica D'Emidio

Distribution
Antonia De Besi

Administration
Grazia De Giosa

Warehouse and Outlet
Roberto Curiale

© 2011
Edizioni Charta, Milano
© Sandi Haber Fifield for her works
© The authors for their texts

All rights reserved
ISBN 978-88-8158-798-8

Printed in Italy
by BIANCA&VOLTA, Truccazzano
for Edizioni Charta

Edizioni Charta srl
Milano
via della Moscova, 27 - 20121
Tel. +39-026598098/026598200
Fax +39-026598577
e-mail: charta@chartaartbooks.it

Charta Books Ltd.
New York City
Tel. +1-313-406-8468
e-mail: international@chartaartbooks.it

To find out more about Charta,
and to learn about our most recent
publications, visit
www.chartaartbooks.it

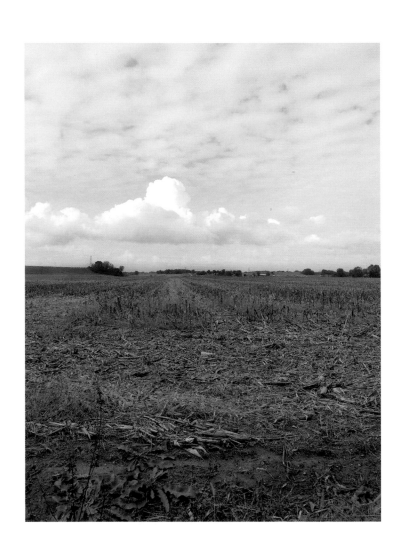